The Art of
EDWARD S. CURTIS

Photographs from *The North American Indian*

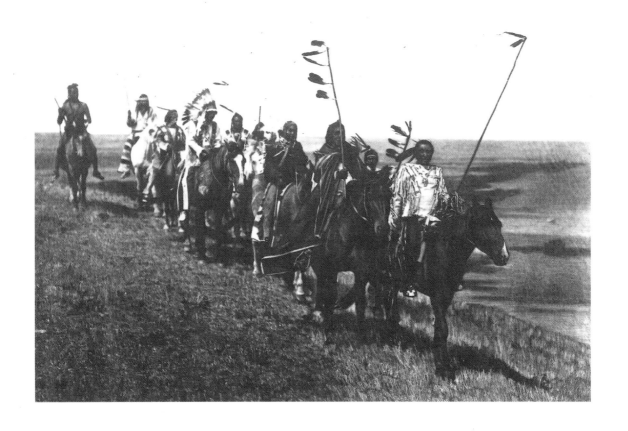

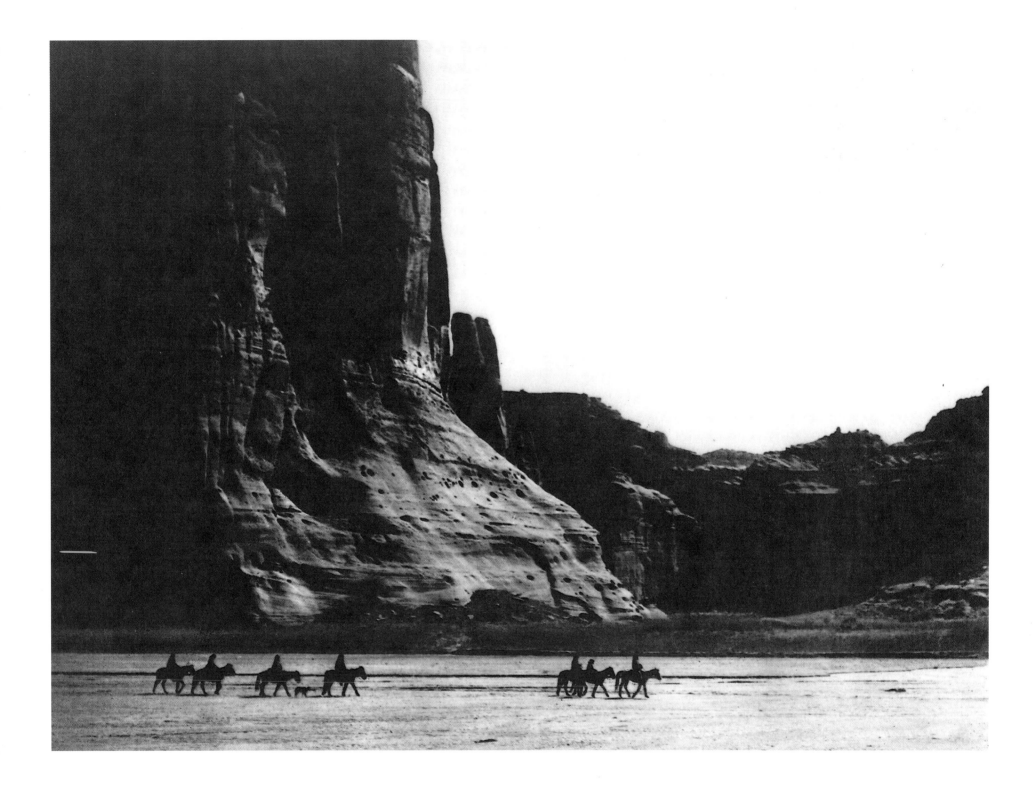

The Art of
EDWARD S. CURTIS

Photographs from *The North American Indian*

Tom Beck

With Images from
**John Work Garrett Library
The Johns Hopkins University**

CHARTWELL
BOOKS, INC.

Published by
CHARTWELL BOOKS
a division of Book Sales, Inc.
Raritan Center
114 Northfield Avenue
Edison, New Jersey 08818

Produced by
Brompton Books Corp.
15 Sherwood Place
Greenwich, Connecticut 06830

ISBN 0-7858-0410-2

Printed in Czech Republic

ACKNOWLEDGMENTS

A number of people have made valuable contributions to this book. Prof. Raymond H. Starr, Jr. is gratefully acknowledged for reading and thoughtfully commenting upon the manuscript. Ms. Judith Gardner-Flint, Garrett Librarian at the Milton S. Eisenhower Library, The Johns Hopkins University, graciously made Curtis's work available for study and reproduction. Ms. Cynthia Requardt, Head of Special Collections at the Milton S. Eisenhower Library, generously permitted the use of the images. James VanRensselaer IV, Senior Medical Photographer at Johns Hopkins, expertly made superb reproductions of Curtis's images. He was ably assisted by Doug Hansen, Medical Photographer, who made many of the beautiful prints.

Steve Kiesow at the Seattle Public Library, made available the correspondence between Curtis and Harriet Leitch. The Interlibrary Loan staff at University of Maryland Baltimore County procured materials from near and far with much appreciated dispatch. Thanks are given to Jo Bateman, Eleanor Danko, and Lidia Schechter. Special thanks go to Gina and Paula.

The following individuals are acknowledged for their help in the preparation of the book: Rita Longabucco, the picture editor; David Eldred, the designer; and Jean Martin, the editor.

All of the images in this book are from the **John Work Garrett Library, Special Collections Department, Milton S. Eisenhower Library of The Johns Hopkins University,** except the following:
The Bettmann Archive: 12.
The Kansas State Historical Society, Topeka, KS: 8.
Library of Congress: 20.
The Metropolitan Museum of Art, The Alfred Stieglitz Collection, 1949 (49.55.167): 17.
National Portrait Gallery, Smithsonian Institution/Art Resource, NY: 16.
Photography Collection, University of Maryland Baltimore County: 10, 19(right), 21(left).
Smithsonian Institution National Anthropological Archives, Bureau of American Ethnology Collection: 6, 9(right).
Special Collections Division, University of Washington Libraries, Seattle, WA: 7, 9(left), 11(left and center), 13, 14, 18, 19(left), 21(right).
Theodore Roosevelt Collection, Harvard College Library: 15.

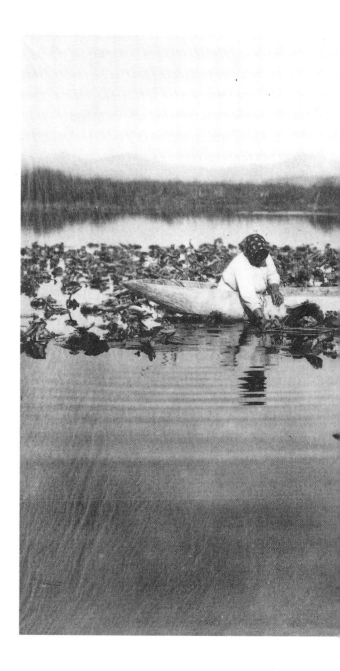

PAGE 1: *On the War-Path, Atsina*

PAGE 2: *Canyon de Chelly, Navaho*

RIGHT: *Gathering Wokas, Klamath*

Contents

Introduction

Nearly a century ago, Edward S. Curtis began photographing Native Americans, yet only in recent years has he begun receiving artistic recognition for his monumental life's work, *The North American Indian*. Curtis became a full-time photographer in the 1890s, when the idea of photography as art was just starting to be accepted. His inventive and highly artistic images argued in favor of the aesthetic qualities of the medium, although he did not take a leading role in the effort to convince the art world.

Curtis was remarkably accomplished as a self-taught photographer, mountaineer, lecturer, film maker, explorer, author, and publisher. In everything he did, his focus was almost exclusively on Native Americans. So ardent was his appreciation of them that he devoted his career to making photographs romanticizing their appearance and customs. Like many others, he believed that they were, in the terms of the time, a "vanishing race" doomed to be culturally if not physically eradicated.

Born February 16, 1868 in Jefferson County, Wisconsin, Edward Curtis knew only poverty as a child. His father, Johnson Curtis, had been a Civil War private and chaplain in the 28th Wisconsin Volunteer Infantry. When Johnson marched off to war in 1862, he carried a small carved box in which he had placed a tintype of his wife Ellen holding their infant son Ray. By the time of his return in 1865, he had lost his youth and health, as disease more than gunfire took its toll on the regiment. However, he did bring back with him a stereoptican lens, which in time would play an important role in shaping the Curtis family future.

In 1873, Edward's grandfather Asahel Curtis, a prosperous grocer and postmaster, offered Johnson and his family the opportunity to work a farm he had purchased in Le Sueur County, Minnesota. Johnson accepted, although ill health prevented him from doing much of the strenuous farm work. The farm was located near the Minnesota River in an area which was once a center of Santee Sioux life. Despite their near eradication in the uprising of 1862, small bands of Santees still lived there. Young Edward Curtis would have seen some from time to time and heard of the uprising that was later called Little Crow's War.

Little Crow, a Santee Sioux chief, had seen conditions go from

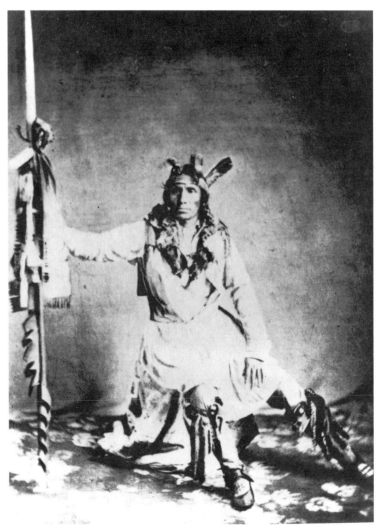

Left: This 1858 photograph of Little Crow, a Santee Sioux chief, was taken by A. Zeno Shindler in Washington, D.C. In 1862, Little Crow led an uprising in Minnesota. The young Edward Curtis undoubtedly heard the story of Little Crow's War while growing up on a farm near the Minnesota River, a former center of Santee Sioux life.

Opposite: A self-portrait of Edward Curtis, taken in 1899 when he was 31 years old.

bad to worse for his people in 1862. The crops were poor for the second year in a row, and the government annuity checks paid to the Santees for giving up their vast lands were late that summer. The Santees had previously received food on credit from government-approved traders, but unfortunately this time the traders wanted to be paid first.

Some young Santee men took matters into their own hands and went hunting off the reservation. Having no success, they climbed a settler's fence and took eggs from a hen's nest. Fearful of the intruders, the settler fled, and the young men pursued him to a nearby house where they caught and killed him, another man, and three women. The killings left Little Crow no choice except war. Even if the young men were turned over to the government authorities, the Santees would not be safe from the settlers' anger.

The Santees attacked the well-armed Fort Ridgely and were repelled. Other battles and skirmishes ranged throughout south central Minnesota, but in the end the Santees lost. Most of them were sent west to reservations, but 38 were executed. Little Crow and his followers escaped to Devil's Lake, North Dakota, and, in the spring of 1863, went to Canada. They were killed by settlers when they returned to Minnesota that summer.

The impact of the Santees' story on young Edward Curtis is not known. He was undoubtedly preoccupied with his chores on the farm which was the family's sustenance until his grandfather's death in 1880 and the farm was sold. The family moved nearby to Cordova where Johnson worked in a grocery store and Edward attended a one-room school, probably his only formal education. Johnson also continued his earlier religious commitment, becoming a part-time preacher for the United Brethren Church. The congregation was scattered over 100 square miles of backwoods, so Johnson traveled frequently to perform weddings and funerals and to provide spiritual comfort. Edward often accompanied his father in his travels and became a knowledgeable outdoorsman.

Edward also made time to pursue his fascination with photography. Using a manual, he built a camera by fitting two boxes together and mounting the lens his father had brought back with him from the Civil War on the front. Later he acquired a copy of *Wilson's Photographics: A Series of Lessons, Accompanied By Notes, On All the Processes Which Are Needful in the Art of Photography.* Included with each lesson were quotes from famous artists and photographers such as Oscar Gustave Rejlander who advised: "Whether the photographer can be called an artist or not, to

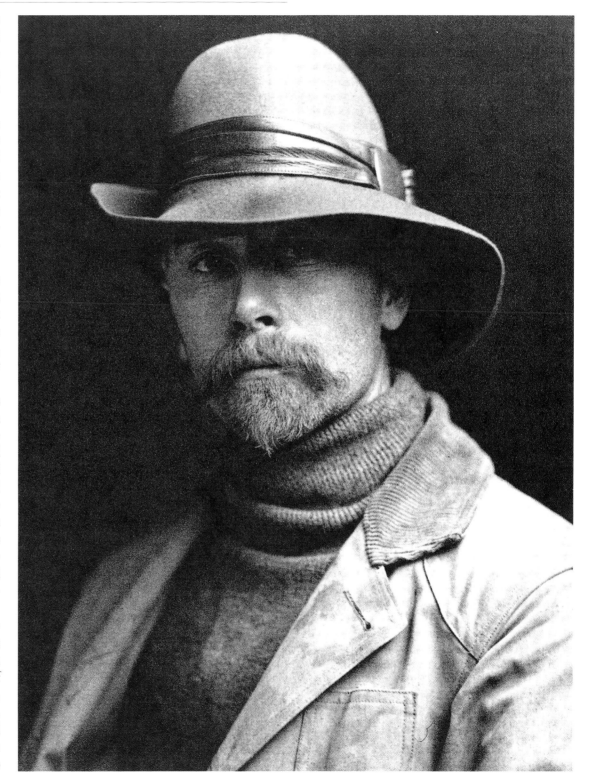

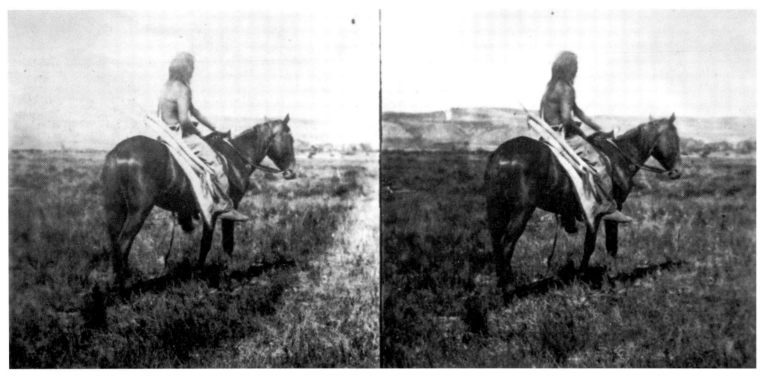

Left: Many painters and photographers were noted for depicting Native Americans in the mid-nineteenth century. This stereoscopic photograph of a Shoshone warrior was made by celebrated landscape painter Albert Bierstadt in 1859.

Opposite left: A portrait of Keokuk (Watchful Fox), chief of the Sauk and Fox tribe, by George Catlin. Catlin had made more than 400 paintings and thousands of sketches of Native Americans by 1836.

Opposite right: This daguerreotype of Keokuk was made in 1847 by Thomas Easterly.

obtain the highest success he must have something of the education and feeling of an artist."

Poor economic conditions motivated Johnson Curtis to leave Minnesota for Washington Territory in the fall of 1887. He and Edward went ahead of the family in search of land. Neighbors from Minnesota who had settled on Puget Sound across from Seattle, near what is now Port Orchard, encouraged Johnson to buy land nearby, which he did. Tragedy struck the following spring when Johnson's health failed and he died of pneumonia just days after Ellen Curtis brought the two younger children (Eva, born 1870, and Asahel, born 1874) from Minnesota to the cabin that Edward and Johnson had built.

Edward Curtis farmed, fished, and chopped wood to support the family. In time, his hard work yielded not only enough to meet their needs, but also to buy a 14-by-17-inch view camera from a miner seeking a grubstake. With $150 mortgaged from the family farm, he bought a part-interest in a Seattle photography studio. In 1892 he married his girlfriend, Clara Phillips, whose family had a farm near the Curtis farm on Puget Sound.

Around this time art became the aspiration of many photographers. Influences from painting, drawing and printmaking found their way into photographs. Moreover, photographers began drawing and painting on negatives, and often employed printing processes such as the platinotype, gum print, and photogravure to produce a soft and atmospheric appearance akin to that achieved by the French Impressionist painters.

The movement known as Pictorialism promoted personal vision and expression in photography. Pictorialists contended that, like paintings, photographs should possess beauty and evoke emotion. Photographers adopted themes and subjects from art that were already critically and publically accepted, such as idealization of rural life, formal portraits, landscapes, nudes, fantasies, allegories, and genre scenes. For example, *Eastward As Far As the Eye Can See*, John G. Bullock's photograph of a woman standing on a rock above the ocean and peering at the horizon with her hand shading her eyes, is reminiscent of paintings on the sentimental theme of waiting for a ship to return. Bullock carefully bisects the image with the horizon line so that the viewer's eye is led first to the woman and then out to sea. The image is both picturesque and artful.

Bullock, like many photographers, recognized the benefits of membership in a camera club through which he could exhibit his prints and associate with other aesthetically-minded photographers. But when his club, the Photographic Society of Philadel-

phia, rejected the growing dominance of the avant-garde, he and his friends resigned and joined the Photo-Secession, a new group founded in 1902 in New York and led by Alfred Stieglitz. A major influence on the aesthetics of photography at the time, Stieglitz set demanding standards and rallied photographers from around the country who had rejected less aesthetically concerned photography in favor of the avant-garde.

Higher standards of aesthetics evidently were an aspiration for Curtis as well. He changed business partners in 1892, and the new partnership took first prize in portraiture at the 1896 National Photographers Convention. Soon thereafter, Curtis became sole proprietor of "Edward S. Curtis, Photographer and

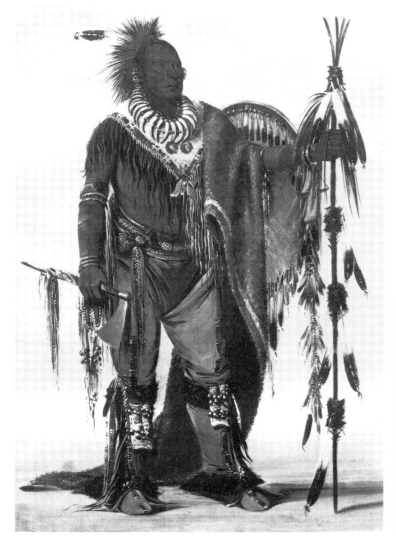

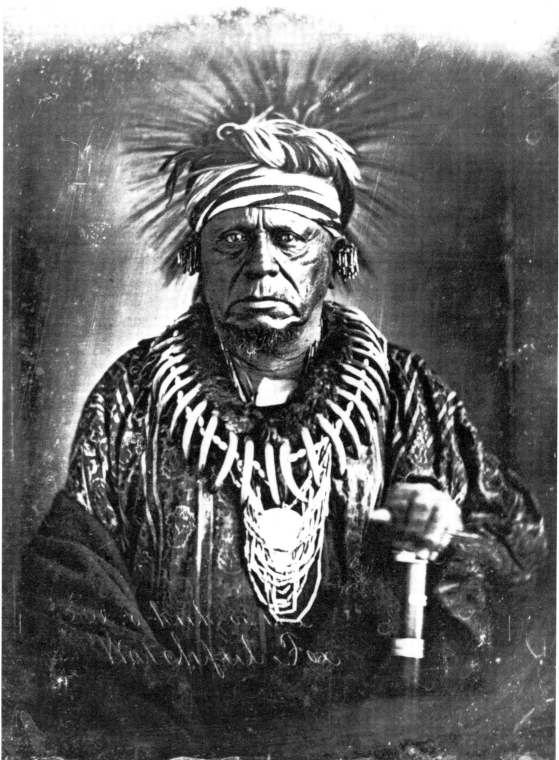

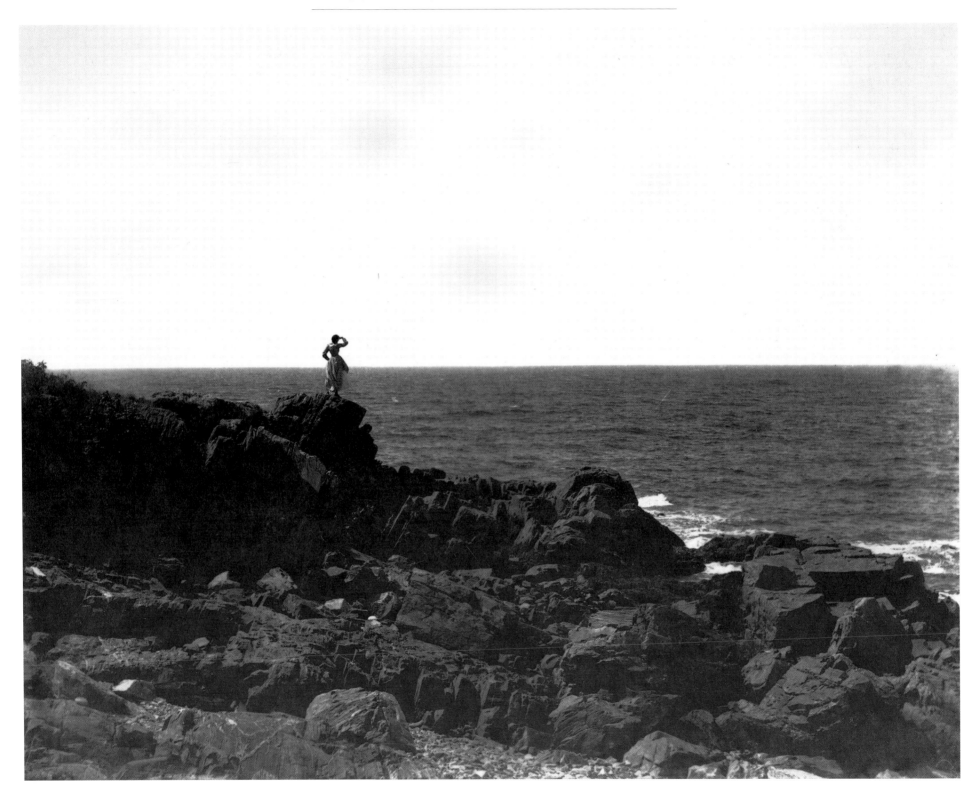

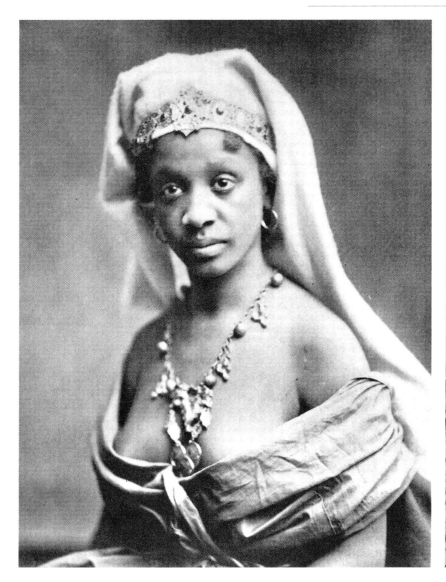

Opposite: John G. Bullock's 1890 photograph *Eastward As Far As the Eye Can See* is a good example of pictorial photography. Pictorialism promoted beauty and the evocation of emotion through balanced composition, the use of chiaroscuro and choice of sentimental subject matter.

Left: Curtis's taste for the exotic is expressed in (far left) *The Desert Queen* and (left) *The Egyptian*, both taken in 1901. These images are inauthentic but are clearly pictorial in style.

Photoengraver." In five short years, he had become owner of a successful studio and photographer to Seattle's aristocracy.

Style was a hallmark of Curtis's portraiture. Not only was his work fashionable, but it was also distinctive in manner of expression. His images were impressionistic, exactingly posed, and expressively lit. In the best pictorial tradition, Curtis's portraiture had balanced composition, well-defined lights and darks, harmonious arrangement, and appealing sentiment. Beauty was the typical statement of a Curtis portrait. He was equally adept at making other kinds of images, such as exotic ones made specifically for exhibition.

Curtis had seemingly boundless energy. He added outings to photograph Native Americans to his regular activities, visiting the Tulalip Reservation (about thirty miles north of Seattle) to photograph the Makah, Quinault, and Salish people as they fished and hunted seals. The arrival of Native American hop pickers each day at the Old Yacht Club dock in Seattle was another photographic opportunity for Curtis. But no occasion quite compared with meeting Princess Angeline, the aged daughter of Seathl, former chief of the Dwamish and allied tribes and namesake of the city of Seattle.

Princess Angeline survived by gathering firewood and digging

clams near her waterfront shack. Curtis found her a most engag-
ing subject who was willing to be photographed once he
promised her one dollar per image. Curtis made the most of her
wrinkled and leathery look, and evoked a pathos he had not pre-
viously achieved in his photographs.

Mountain climbing was yet another of Curtis's passions. He
had reached the summit of Mt. Rainier (14,410 feet) many times
by the most difficult routes and made photographs along the
way. In 1898, he and a studio assistant were making an ascent
when they chanced upon a group of lost climbers. Curtis led
them back to his camp, warmed and fed them, and learned that
they were distinguished scientists, including C. Hart Merriam
(head of the U.S. Biological Survey), Gifford Pinchot (newly
appointed chief of the U.S. Forestry Service), and George Bird
Grinnell (ethnologist, editor of *Forest and Stream* magazine, and
founder of the Audubon Society). Curtis agreed to serve as their
guide for several days, and later entertained them in Seattle
where the group admired his photographs of Native Americans.

Grinnell especially appreciated Curtis's work and invited him
to join a scientific expedition to Alaska from May 30 through
July 30, 1899, organized by railroad magnate and financier
Edward H. Harriman. Thirty-nine scientists and artists accom-
panied eleven members of the Harriman party on the trip.

As official photographer, Curtis invited his friend Duncan
Inverarity along as his assistant, and they made several hundred
photographs. One image nearly cost them their lives. Curtis and
Inverarity had paddled their canvas canoe very close to the wall
of Muir Glacier to make a close-up view. Just then about half a
mile of the glacier broke off, fell into the bay, and created a
tremendous series of waves and a rain of shattered ice.
Onlookers on the shore and aboard the boat were sure that the
canoe had been sunk by the falling glacier and resulting waves,
but the photographers had paddled away at the last possible
moment and then wisely turned their craft into the waves. A
combination of luck and skill permitted them to avoid disaster,
but water in the canoe destroyed the exposure on the glass plate.

The expedition was more than a photo opportunity for Curtis;
it substituted in part for the formal education he never had.
Various experts lectured each evening: John Muir on glaciers,
John Burroughs on birds, and Henry Gannett on geography. He
also had access to a 500-volume reference library on board the
boat.

One person with whom Curtis spent considerable time was
George Bird Grinnell. Curtis heard his lecture recounting twenty

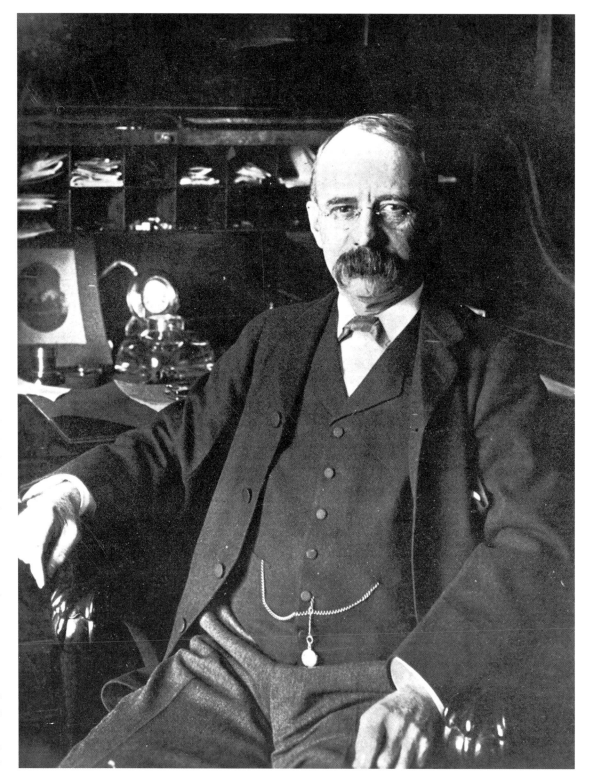

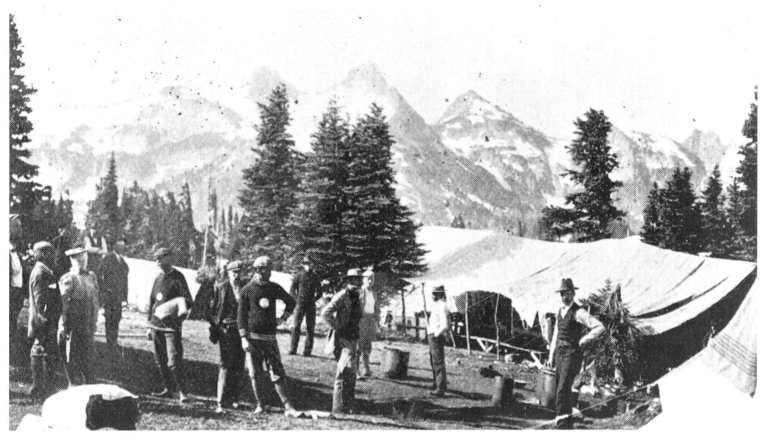

Opposite: Railroad magnate and financier Edward H. Harriman (1848-1909) sponsored the 1899 scientific expedition to Alaska in which Curtis served as official photographer. Curtis's experience on this trip served him well in his later work.

Left: In 1897 Curtis photographed the base camp of the Mazamas, a mountain-climbing group based in Portland, Oregon. An experienced climber, he led the group to the summit of Mt. Rainier (14,410 feet) in Washington. On another ascent of that peak, in 1898, Curtis assisted a group of lost climbers who were noted scientists. This meeting led to Curtis's involvement in the Harriman expedition.

years of experience with the Blackfeet and the two men no doubt discussed in depth their mutual interest in Native Americans. Grinnell had written extensively about the Cheyenne and Blackfeet tribes, and imparted his knowledge of ethnography and ethnographic research to Curtis.

The end result of the Harriman expedition was 14 volumes of text and images exhaustively reporting the data and observations from the trip. Publication took 15 years and untold funding from Harriman to complete. Photographs by Curtis and others illustrated most of the volumes and were expertly reproduced in photogravures.

In the summer of 1900, Grinnell and Curtis traveled to northern Montana to witness the Sun Dance performed by the Blood, Blackfeet and Algonquin tribes. Looking down from a high cliff at the mile-wide circular encampment below, Curtis was, as he described later, "intensely affected." "It was the start of my effort to learn about the Plains [Indians] and to photograph their lives," he said. Within days of his return to Seattle, Curtis left

again to embark on what became his life's work. He had resolved to photograph all the major Western tribes.

Fear that the Native Americans would eventually vanish was a strong motivation for interest in them as early as 1828, when Justice Joseph Story said: "By a law of their nature, they seem destined to a slow, but sure extinction...they pass mournfully by us, and they return no more." Similar sentiments were expressed throughout the nineteenth century as the Native Americans' dominance over the land diminished and their cultures were destroyed. Among those who sought to preserve the look and manner of the Native Americans was George Catlin, who gave up a law career to paint.

Catlin's first trip west in 1832 was financed by William F. Stone, a New York publisher. By 1836, Catlin had created over 400 paintings and thousands of sketches, and had visited at least 48 tribes. He attempted to recover his substantial expenses through a very popular exhibition in New York in 1837, but his lack of business acumen resulted in losses. Numerous other

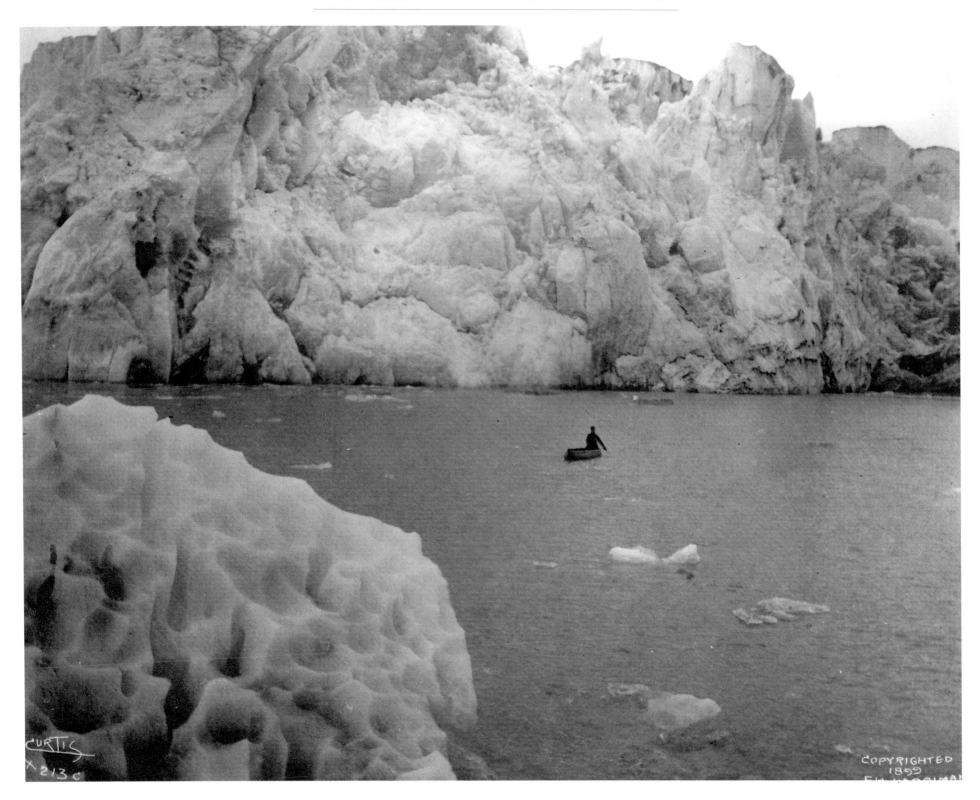

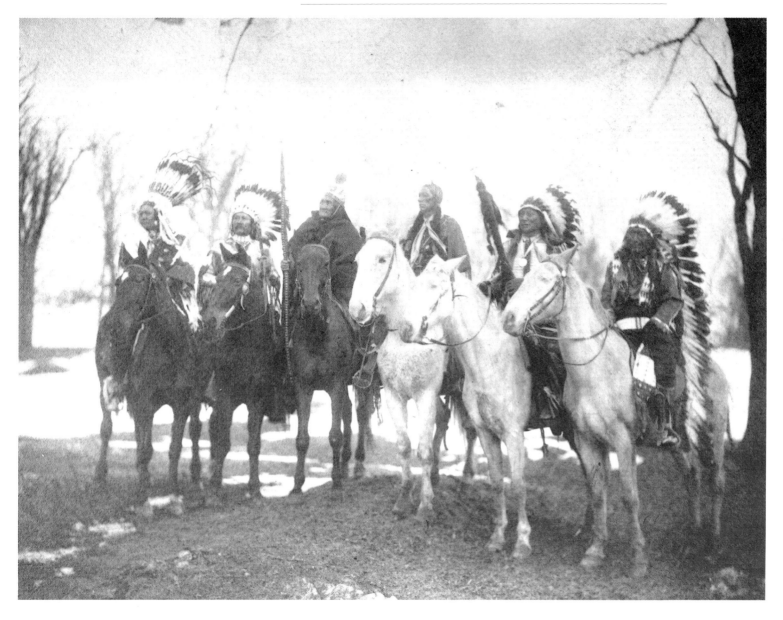

Opposite: Curtis took this dramatic photograph of Muir Glacier in Alaska while on the Harriman trip in 1899.

Left: Curtis was the official photographer at Theodore Roosevelt's inauguration in 1905. Among the participants in the inaugural parade were six Indian chiefs from various tribes, including the aged Geronimo (third from left), whom Curtis photographed astride their horses on the White House lawn.

schemes ended similarly. By 1852 Catlin was so heavily in debt that his collection was in danger of being divided among his creditors. However, a wealthy American boiler-maker, Joseph Harrison, purchased the whole collection, and eventually the Smithsonian Institution acquired it.

Motives similar to Catlin's inspired others, particularly Edward Curtis, who was concerned that Native American traditions were vanishing and insufficiently documented. Like Catlin, Curtis wanted to show Native Americans in context. In 1904

Curtis hired Adolf Muhr, a noted photographer and darkroom expert, to manage his studio, leaving Curtis largely free to travel and make photographs. Expenses for the grand endeavor Curtis had envisioned would be high, and eventually in 1906 he would find the financial assistance he needed.

In 1903, Curtis had sent a photograph of Marie Octavia Fischer to the *Ladies Home Journal* in response to a solicitation for images of "The Prettiest Children in America." Walter Russell, a noted portrait painter, then selected 12 children whom

he visited and portrayed in oil paintings for publication in the magazine. Curtis's photograph was one of those selected, and when Russell visited Seattle to make the painting of Marie Fischer, he and Curtis became acquainted.

Several weeks later Russell sent Curtis a telegram inviting him to make portraits of President Theodore Roosevelt's sons to serve as models for paintings Russell would make. Curtis traveled from Seattle to Oyster Bay, New York, in June 1904. He photographed the whole Roosevelt family and made the acquaintance of the President, who admired the photographs of Native Americans that Curtis had brought along. Roosevelt reinforced Curtis's goal of creating an extensive survey of Native Americans, but in Roosevelt's view it would be a record of the valor involved in their conquest.

Roosevelt later provided Curtis with a letter of reference he could use in approaching possible benefactors for support. Among those who had purchased Curtis's prints at shows in New York were J.P. Morgan's favorite daughter, and his daughter-in-law. Curtis made an appointment to see Morgan in early 1906, and sent ahead a prospectus for the project with suggestions for ways in which a benefactor could recoup his investment in the work.

Curtis might have asked Morgan for an outright grant and saved the investment idea as an alternative, but having already presented the plan, there was no negotiating. Based upon the $25,000 he had spent of his own money over five years, Curtis estimated that $15,000 a year for field expenses would be sufficient to complete the project in five more years. Morgan, who was noted for his impatience, gave Curtis just a few minutes to make his appeal. Curtis insisted upon showing the work he had done so far, and only after seeing some of the images did Morgan succumb and offer Curtis the needed funds. Subsequent meetings between Curtis and Morgan set the terms which in time proved impossible for Curtis to fulfill.

Many photographers throughout the history of the medium have proven to be notoriously bad at business; Curtis was no exception. He envisioned 20 volumes of images and text with 20 accompanying portfolios of large, high quality photogravures to be completed in five years. Publishers he had approached considered such a publication too expensive and risky. Morgan convinced Curtis to publish the work himself and to cut the profit margin in order to sell the volumes at $3,000 a set ($4,500 for the deluxe sets). In return for his $75,000 investment, Morgan would receive 25 sets and 500 original photographs. This turned

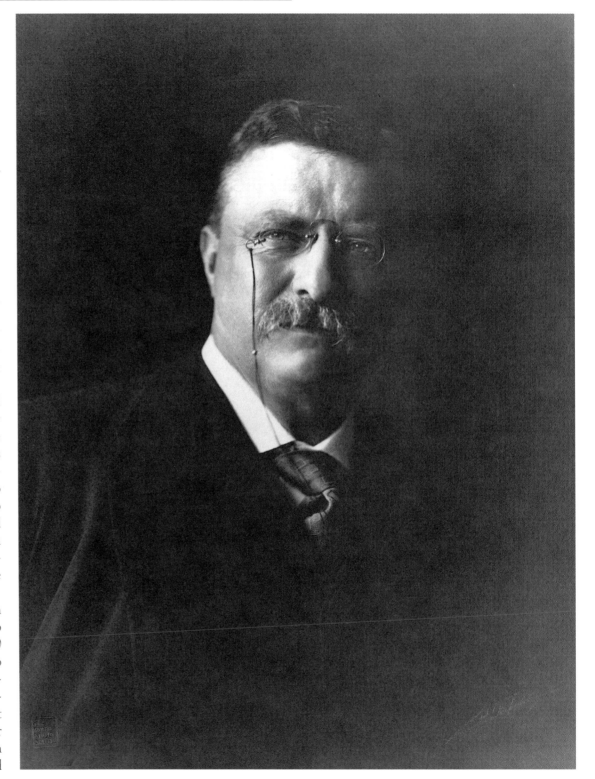

out to be an incredibly bad deal for Curtis, because his salary was not factored into the arrangements. Since the funds for printing the books would be generated from advance sales of the 500 sets to be produced, Curtis was responsible not only for the photography, fieldwork, and text, but also for the design, marketing, fundraising, and sales and distribution of the publication. The administrative and creative burdens were overwhelming.

Working 16 or more hours a day, seven days a week, Curtis was a veritable blur. The months when he was not in the field or writing, were spent on the road lecturing, presenting exhibitions, supervising the publication effort, and promoting sales. Having established a New York office for *The North American Indian*, he criss-crossed the country several times each year, spending little time at home.

The initially slow publication pace quickened, as the editing and printing caught up with the photography and writing. Volume one appeared in 1907, and succeeding volumes, through volume 11, appeared before World War I. The text was edited by Frederick Webb Hodge, Director of the Bureau of American Ethnology at the Smithsonian Institution. Volumes six through eight all appeared in 1911, the last year of funding from Morgan. During World War I, printing ceased because European paper was not available, but resumed again in time for volume 12 to appear in 1922.

Curtis achieved widespread recognition as his images proliferated and newspapers covered his exhibitions, lectures, and other publicity generating activities. Moreover, his identification with Morgan won him national and international coverage. Newspaper headlines such as, "Morgan Money to Save Indians from Oblivion" and "Mr. Morgan's Help for Indian Photographer" publicized Curtis's work. Articles chronicling Curtis's exploits, such as one in the *New York Times* in 1911 telling of his induction as a member of the Hopi Snake Order, contributed to Curtis's fame.

Dark clouds inevitably appeared on Curtis's horizon. After the Morgan funds were depleted, Curtis was more desperate than ever for a means to fulfill his promises to subscribers. Like Catlin before him, scheme after scheme failed to yield the expected profits. A touring picture "musicale," an evening of projected images and Native American music scored for an orchestra, cost more to stage than it generated in ticket sales. A feature film, *In the Land of the Headhunters*, that Curtis expected to generate substantial profits, was not a financial success. Moreover, Rodman Wanamaker, the department store heir, imi-

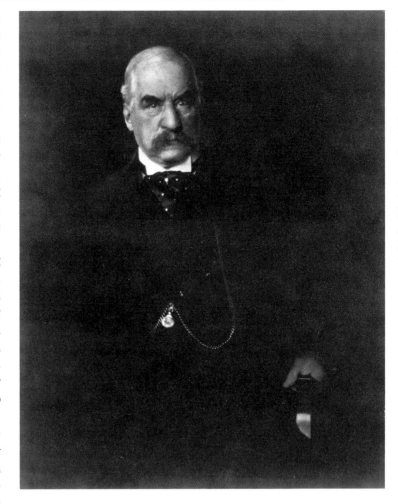

Opposite: Curtis's official presidential portrait of Theodore Roosevelt, taken in 1904, demonstrates that Curtis was indeed one of the great portrait photographers of his generation. The raking light in Curtis's pictorial image renders the president dignified and aristocratic.

Left: This famous portrait of John Pierpont Morgan, the financier who funded much of Curtis's monumental project *The North American Indian*, was taken by Edward Steichen.

tated Curtis's style of imagery in his own photographs of Native Americans. Near bankruptcy, Curtis signed a second mortgage on his house, but neglected to inform his wife.

While Clara Curtis did not share her husband's interest in photography, she certainly appreciated his long climb from abject poverty to his success as a studio owner and fame as an artist. She even helped operate the studio during his many long absences. However, she surely did not appreciate the family resources being expended on his obsession with *The North American Indian*. Tensions between Clara and Edward must have become unbearable during his 1909 summer visit to Seattle, because his residence thereafter was the Rainier Club. To make matters worse, their son Harold went to live permanently with wealthy foster parents in New Haven, Connecticut.

Through all his difficulties, Curtis persisted in his goal of com-

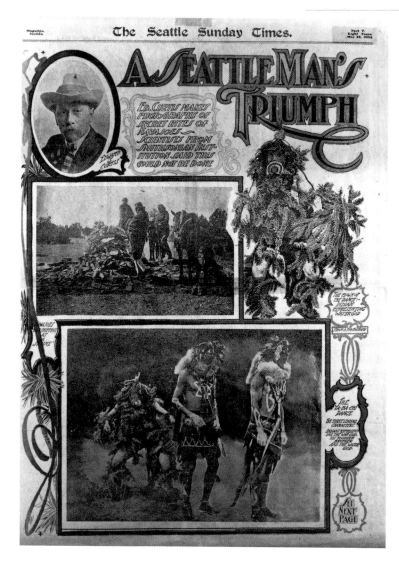

alleged that he had not paid alimony for the last seven years and that he owed her a total of $4,400, excluding interest. In court, Curtis declared that he had no money, even though he had been working for the North American Indian, Incorporated. The judge was astounded to learn that Curtis received no remuneration, and Curtis replied: "Your honor, it was my job. The only thing I could do which was worthwhile. A sort of life's work."

Curtis had many reasons to be tired after the Alaska trip. The destination had been the Diomede Islands in the Bering Strait via Nunivak Island, Nome and Kotzebue, but the group encountered towering waves, foul weather, pack ice, fog, and icebergs. In thick fog, the boat hit a shoal 20 miles from shore in the Diomedes and the engine died, but the worst was yet to come. A storm struck so quickly that there was no time to find a safe harbor. The force of the storm broke an anchor chain and the group had to weather the five-day storm tethered to only one anchor, which resulted in the boat wildly swinging about in seas as high as the mast.

The storm delayed their return, putting them at risk of being trapped by winter weather. Indeed they were caught in a blizzard so fierce that in 24 hours they had been driven back to where they had started, and there was a foot of water below the decks. However, they made such progress after the storm that Curtis could not resist stopping to make some pictures at Wales, the Alaskan mainland village nearest Siberia.

With that delay, they found themselves caught in gale force winds which pushed them ahead of still worse weather. The last wireless message from the north reported that they were certain to have been lost at sea. Shipping around Nome had come to a standstill, and two men had been killed in accidents caused by the high winds. When Curtis and his crew finally arrived at Nome, he said, "Every inhabitant of the village was down to the landing to greet us."

This harrowing trip to Alaska was Curtis's last fieldwork for *The North American Indian*. His daughter Beth had provided the financial and emotional support to make the voyage possible. The Morgan family, in honor of the deceased J.P. Morgan, provided the funding to print the remaining two volumes, which appeared in 1930, when Curtis was 62 years old. In the introduction to the last volume, Curtis thanked all who had helped him and said, "It is finished" – quite an understatement for more than 25 years of work and a dream come true at last.

Family and friends congratulated him for having finished the project, but there was no grand celebration. Moreover, by this

Left: The cover of the magazine section of the *Seattle Sunday Times* of May 22, 1904, heralds Curtis's work photographing Navaho rituals.

Opposite left and right: Curtis's highly artistic style, demonstrated by this 1903 portrait of Nez Percé chief Joseph (left), was imitated by Rodman Wanamaker in his 1913 portrait *White Man Runs Him, Custer Scout* (right).

pleting his survey of Native Americans. Clara filed for divorce in 1916, but the case was delayed because Curtis was constantly in the field and could not appear in court. Having failed to pay alimony, he was cited for contempt of court in 1918. The divorce was not settled until 1920, when the court awarded Clara nearly everything Curtis owned, including the studio and his precious negatives of Native Americans. Curtis then moved to Los Angeles and opened a new Curtis Studio with his daughter, Beth.

Matters between Curtis and Clara, however, remained unresolved. In 1927, when Curtis returned through Seattle from a rather difficult trip to Alaska and was about to board a train to Los Angeles, he was arrested and taken to the county jail. Clara

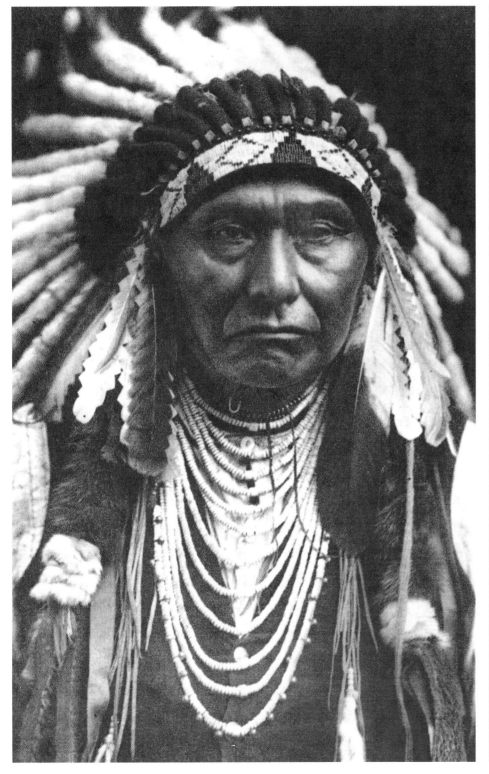
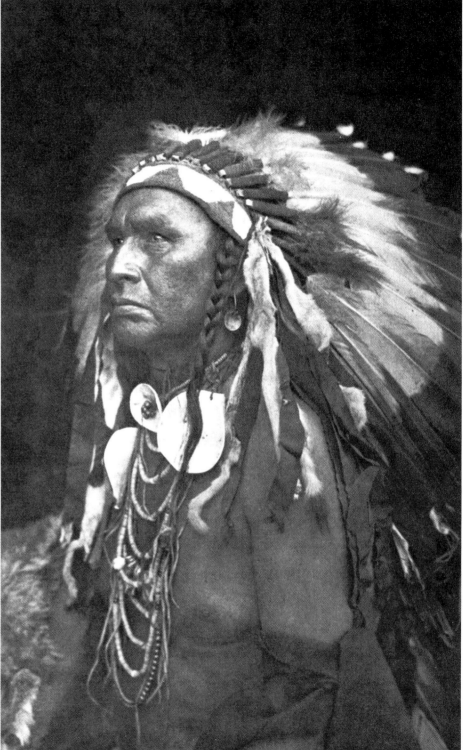

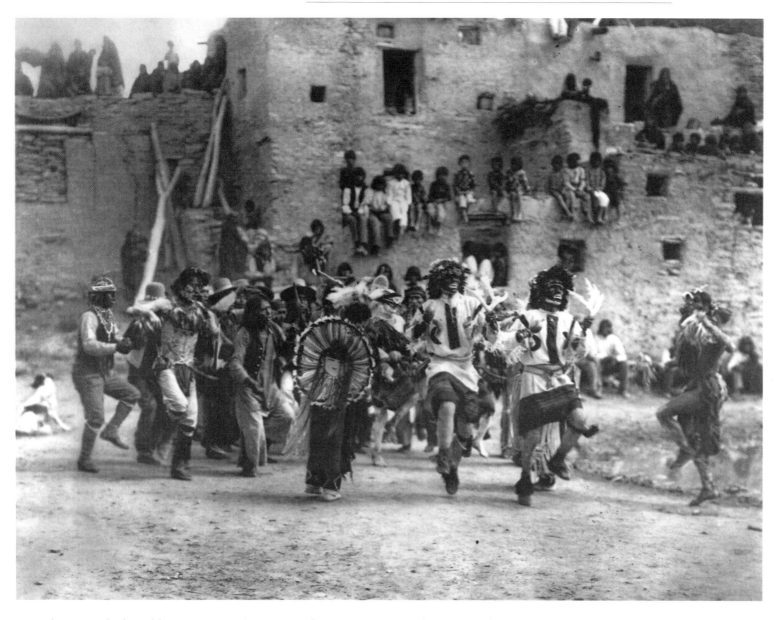

time there was little public interest in Curtis; people were pre-occupied by the Depression.

Curtis spent two years suffering from various health problems, including mental depression caused by feeling at a loss for what to do with the rest of his life. As he gradually regained his health, he found new pursuits. In 1936, he worked on the motion picture *The Plainsman* (starring Gary Cooper), which was filmed in the same part of South Dakota where years before he had photographed the Sioux chief Red Cloud.

The interest that primarily occupied Curtis toward the end of his life was gold mining. In the late 1930s, he worked a mine in Colfax, California. He and three others got caught in a snowstorm there and had to hike 18 miles in knee-deep snow to safety. In the 1940s, research for a book tentatively titled *The Lure of Gold* became his passion. He confessed in a letter to Harriet Leitch, a retired Seattle librarian who sought information about the author of *The North American Indian*, that writing a history of the pursuit of gold might be "trying to tackle a task

too big" for him. Unlike his magnum opus, Curtis never finished *The Lure of Gold*. The project was too immense and his health too frail. He died on October 19, 1952 of a heart attack while visiting his daughter, Beth.

Curtis's death hardly received notice. *The North American Indian* was largely forgotten and Curtis's sentimental style of pictorial photography had passed from fashion. In the 1970s, however, his work was rediscovered through publication and several museum exhibitions, and scholars began to give Curtis the artistic recognition he richly deserved. Finally, his artistic vision has earned him a lasting place in history.

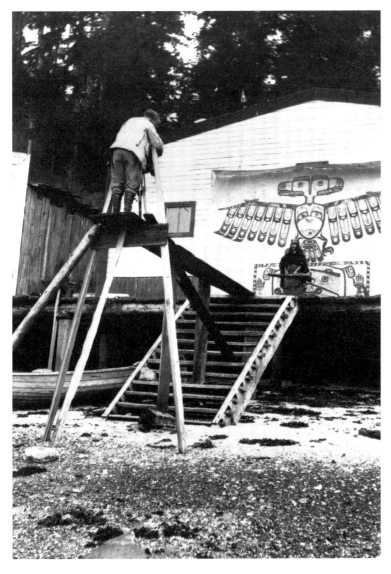

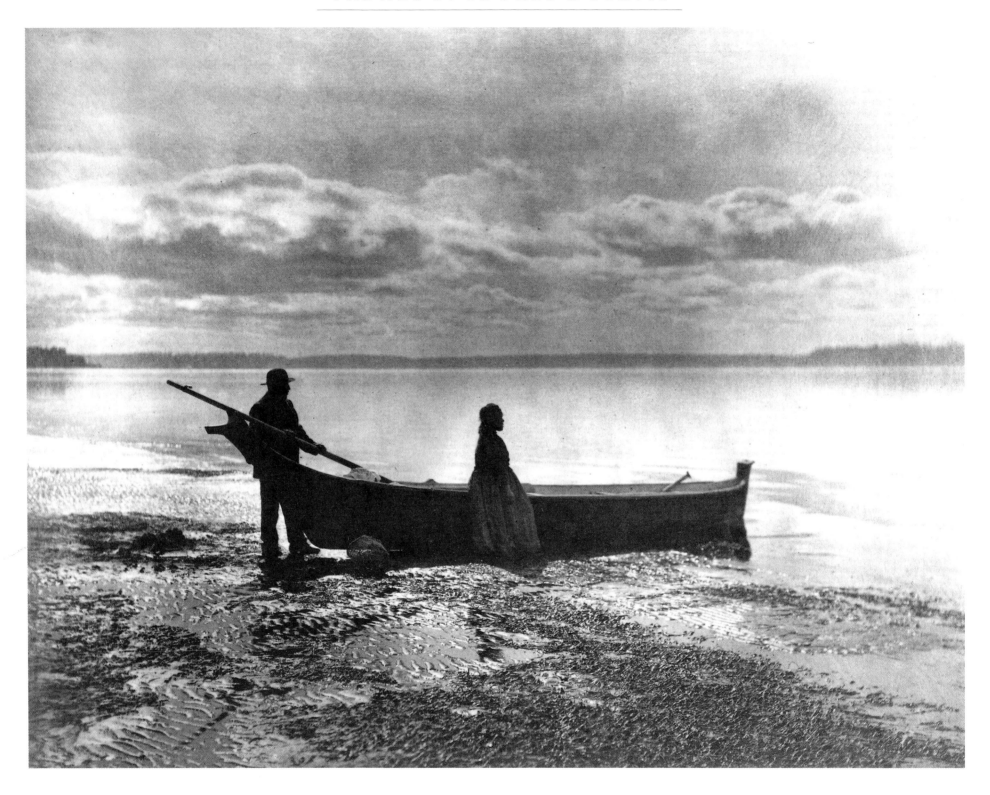

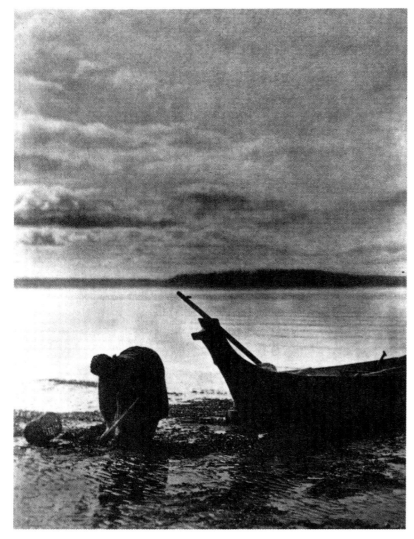

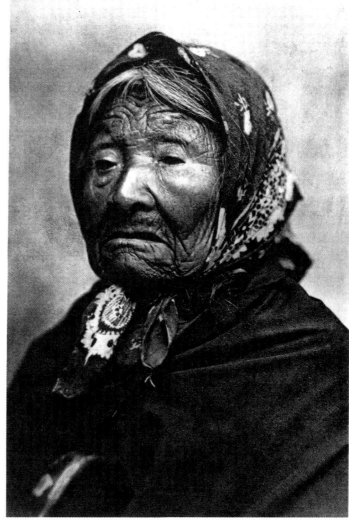

Dates for Curtis's images are often uncertain, since records are either sketchy or nonexistent. Where dates are known, or may be approximated, they are included with the captions. The year of copyright, rarely the year Curtis made the image, is included to indicate the date prior to which the image would have been made.

OPPOSITE:

Evening on Puget Sound, circa 1896, copyright 1899

Beginning around 1896, Curtis spent increasing amounts of time away from his studio in Seattle. Images such as this one provided the opportunity for him to try pictorial arrangements that were different from those of portraiture.

ABOVE LEFT:

The Clam Digger, circa 1896, copyright 1900

Curtis's interest in photographing Native Americans was enhanced when he met Princess Angeline, the aged daughter of Chief Seathl, while she was digging clams near her shack on Puget Sound.

ABOVE:

Princess Angeline, circa 1896, copyright 1899

Curtis's technique of keeping his camera below eye level monumentalized Princess Angeline and, more significantly, made her appear noble. Such expressive quality was a hallmark of Curtis's portraits made in and out of the studio.

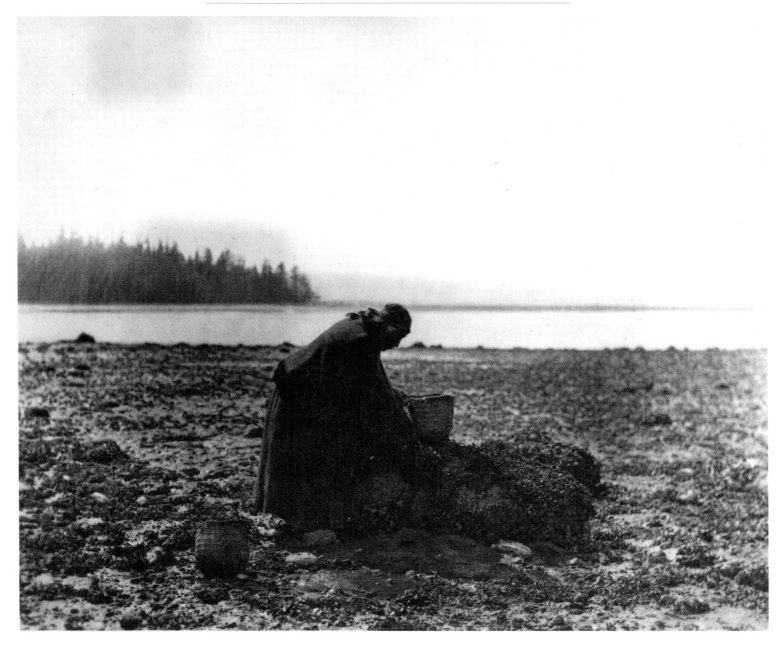

ABOVE:

The Mussel Gatherer, circa 1896, copyright 1900

In the tradition of nineteenth-century landscape painters such as
Jean Baptiste Camille Corot, Curtis placed the center of interest in
an oval arrangement in the lower portion of the image. Moreover, he
aligned the subject's head with the horizon, a typical pictorial
approach.

OPPOSITE:

Sunset on Puget Sound, circa 1896, copyright 1898

Images of Native Americans made by Curtis before 1900 were
intended for exhibition and sale, and only later were incorporated
into *The North American Indian* with an ethnographic text. The
artistic intentions of the images were maintained in the publication.

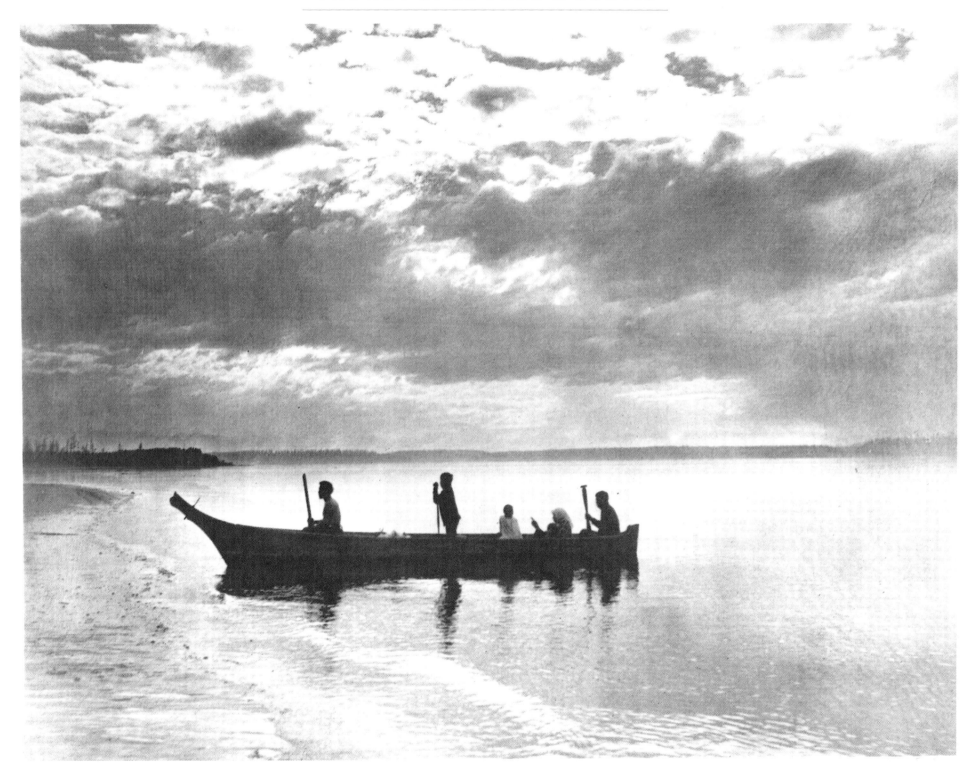

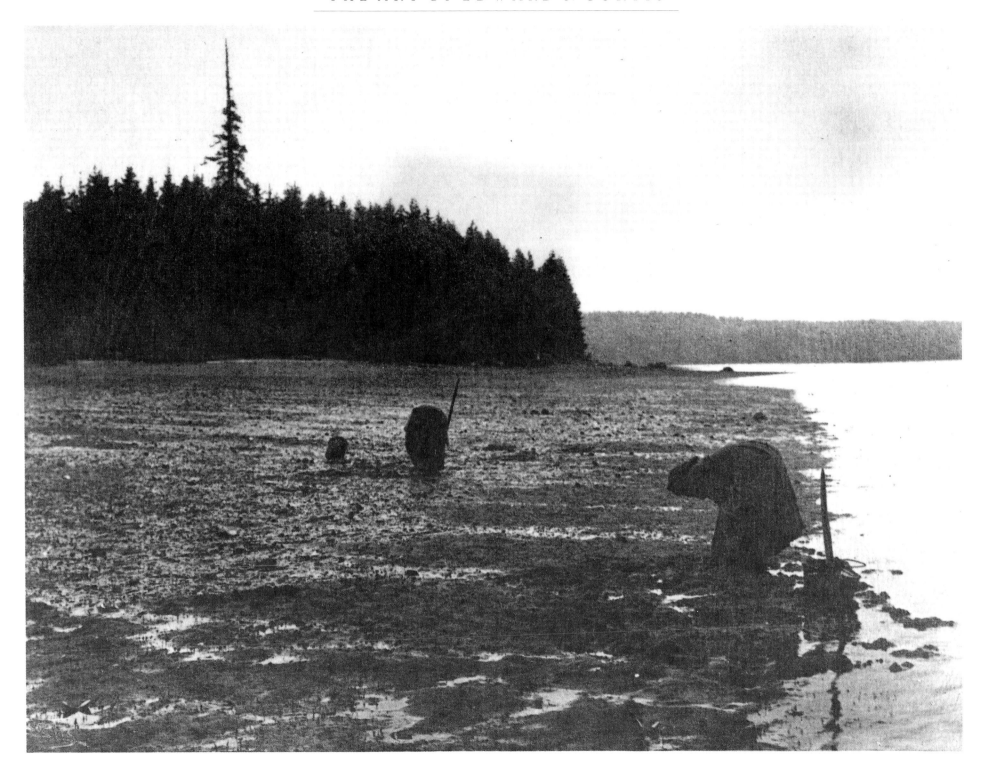

OPPOSITE:
Digging Clams, Puget Sound, circa 1896, copyright 1912

Good pictorial photographs are not necessarily also good
ethnographic images, as this one demonstrates. One can hardly
recognize that the subjects are digging clams. More important to
Curtis was the atmosphere of the image and the symmetry between
the tall tree on the left and the handle of the tool on the right.

RIGHT:
Hop Pickers, Puget Sound, circa 1896, copyright 1898

Although Curtis had been photographing Northwest tribes for years
before commencing work on *The North American Indian*, not until
volume nine were those images included in his survey. The logic
behind the contents of individual volumes is not entirely clear; whole
volumes were devoted to some tribes, while some volumes contained
images of several tribes.

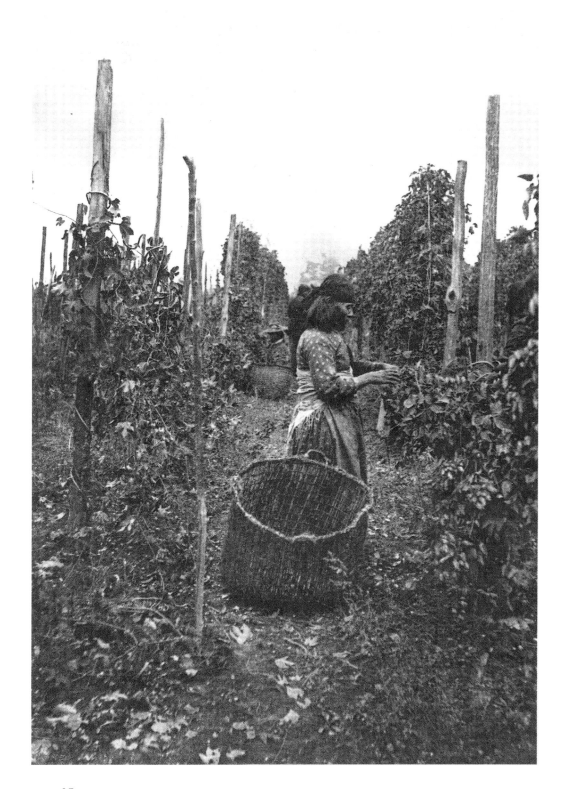

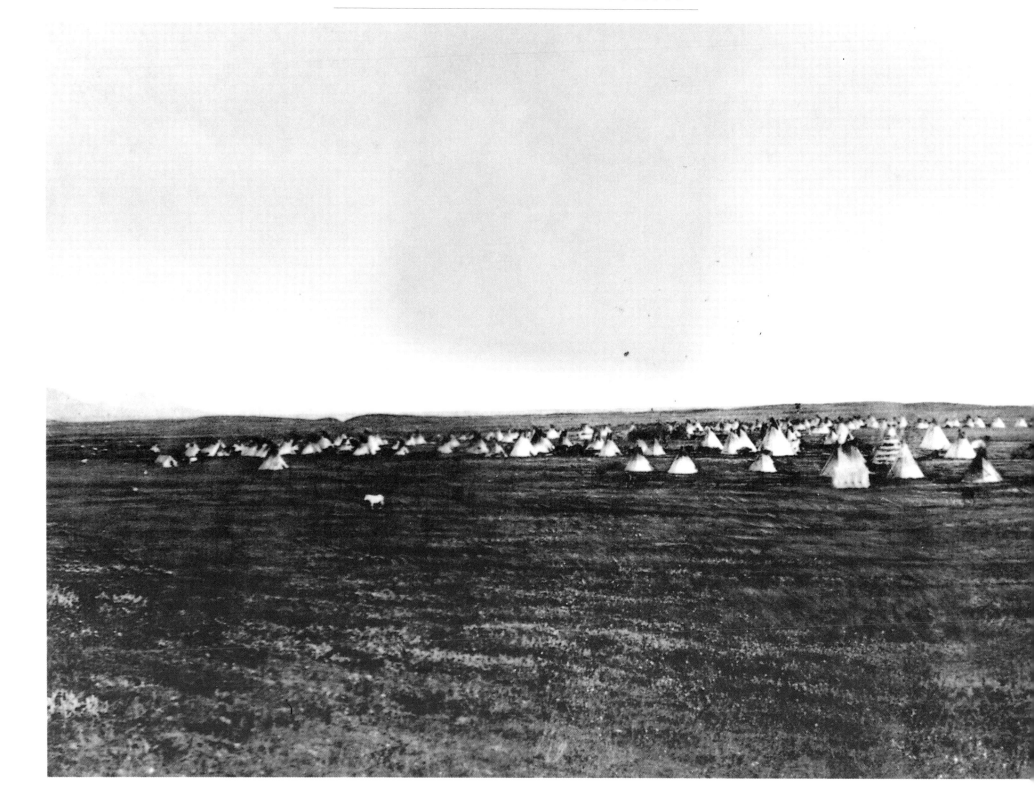

Sun Dance Encampment, Piegan, 1900, copyright 1900

Looking down from a high cliff at the circular encampment of the Blood, Blackfeet and Algonquin below, Curtis was, as he described later, "intensely affected." He resolved to learn about and photograph the major Western tribes based upon that experience.

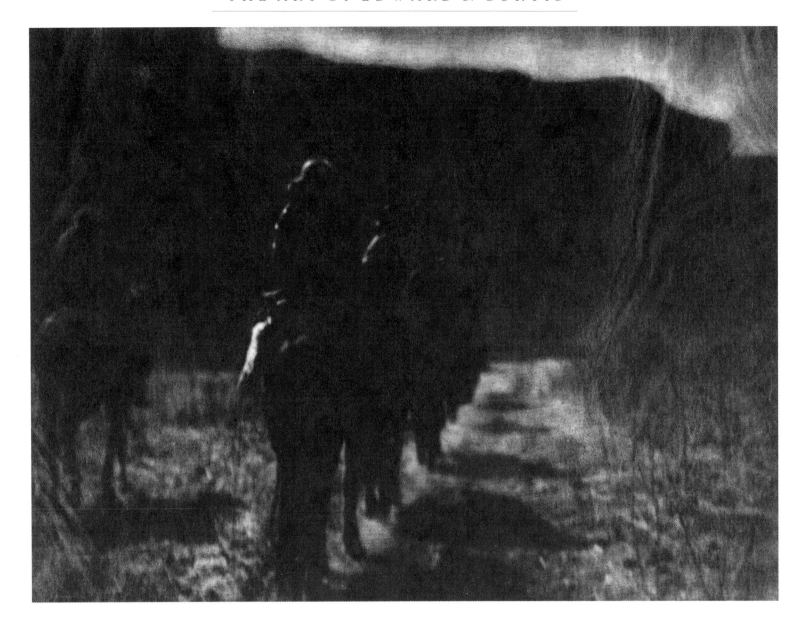

ABOVE:

The Vanishing Race, Navaho, copyright 1904

True to his pictorialist roots, Curtis said of this image: "...shorn of their tribal strength...(Native Americans) are passing into the darkness of an unknown future. Feeling that the picture expresses so much of the thought that inspired the entire work, the author chose it as the first in the series." One critic observed that the image had a "haunting mysticism rarely found in pictures."

OPPOSITE:

The Three Chiefs, Piegan, 1900, copyright 1900

Curtis won much praise for this image, particularly from pictorial photographer Arnold Genthe who proclaimed how much he liked the photograph, but felt that a better arrangement of the horses would have improved the image. Depicted on the upland prairie of Montana are Four Horns, Small Leggings and Mountain Chief.

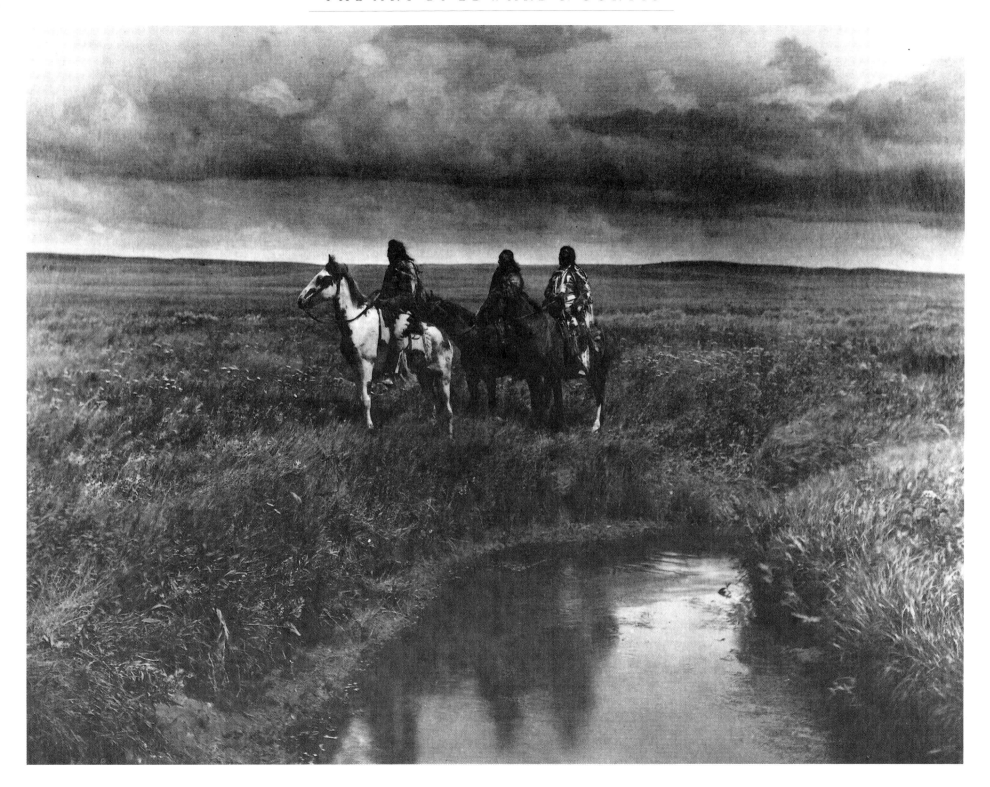

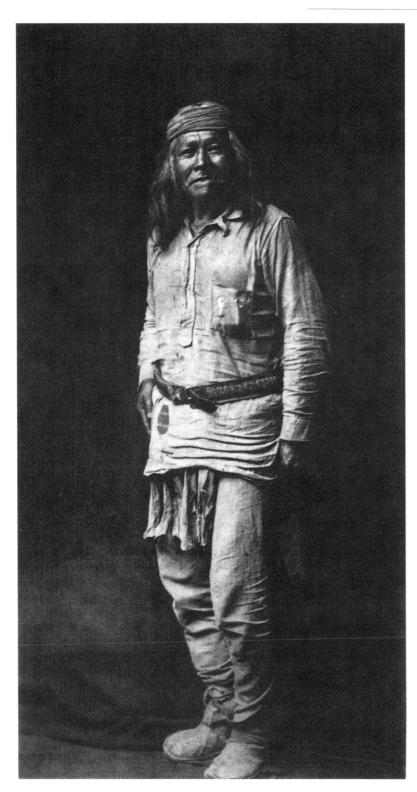

LEFT:

Typical Apache, copyright 1906

Perhaps one reason Curtis preferred making portraits of Native Americans rather than Seattle socialites was the greater expressiveness he could explore in portraying the former as compared to the latter. In this image, for example, he played upon the stereotype of the Apache being warriors even though the portrait was made in a studio tent with a backdrop.

OPPOSITE:

Geronimo, Apache, 1905, copyright 1907

Geronimo, who was about 76 when this photograph was taken, had lived under military supervision for 19 years at various locations when Curtis photographed him at Carlisle, Pennsylvania. Curtis stopped there enroute from a successful exhibition in New York to Theodore Roosevelt's inauguration in Washington, D.C. Heavily retouched, the image depicts Geronimo as firm and unyielding.

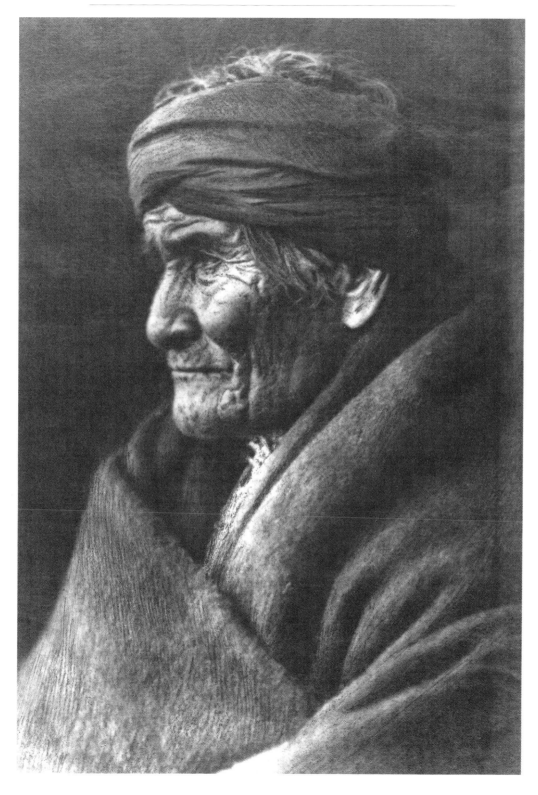

ABOVE:
Sacred Buckskin, Apache, 1906, copyright 1907

Relatively little was known about Apache religion before Curtis's field work on the subject. His sympathy for and interest in Native Americans helped him gain their confidence. He purchased this very potent medicine skin from the widow of a powerful medicine man, and, with supplementary information, was able to decode the cosmology of the Apache.

OPPOSITE:
Apache Girl, copyright 1906

Curtis retouched the eyes in this image to add intensity to an already powerful portrait. Retouching had long been a tool of portrait photographers seeking to flatter sitters. Curtis used the technique primarily for expressive purposes in his portraits of Native Americans.

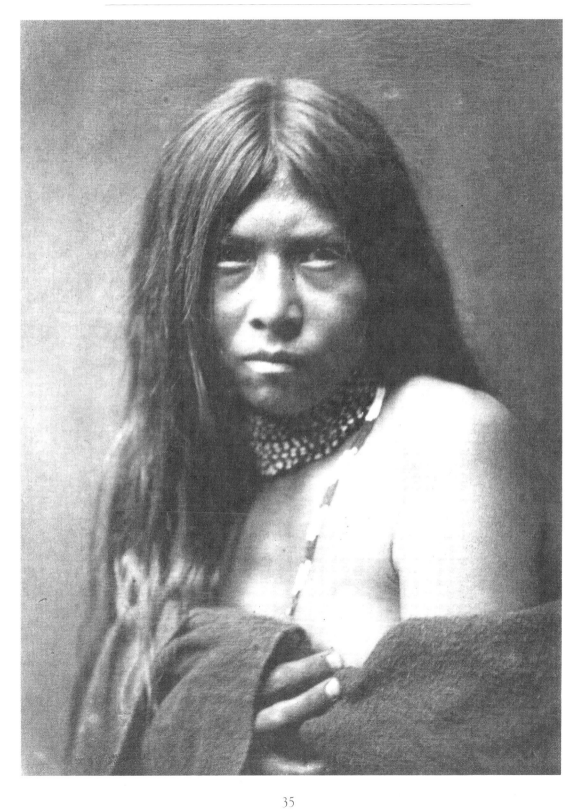

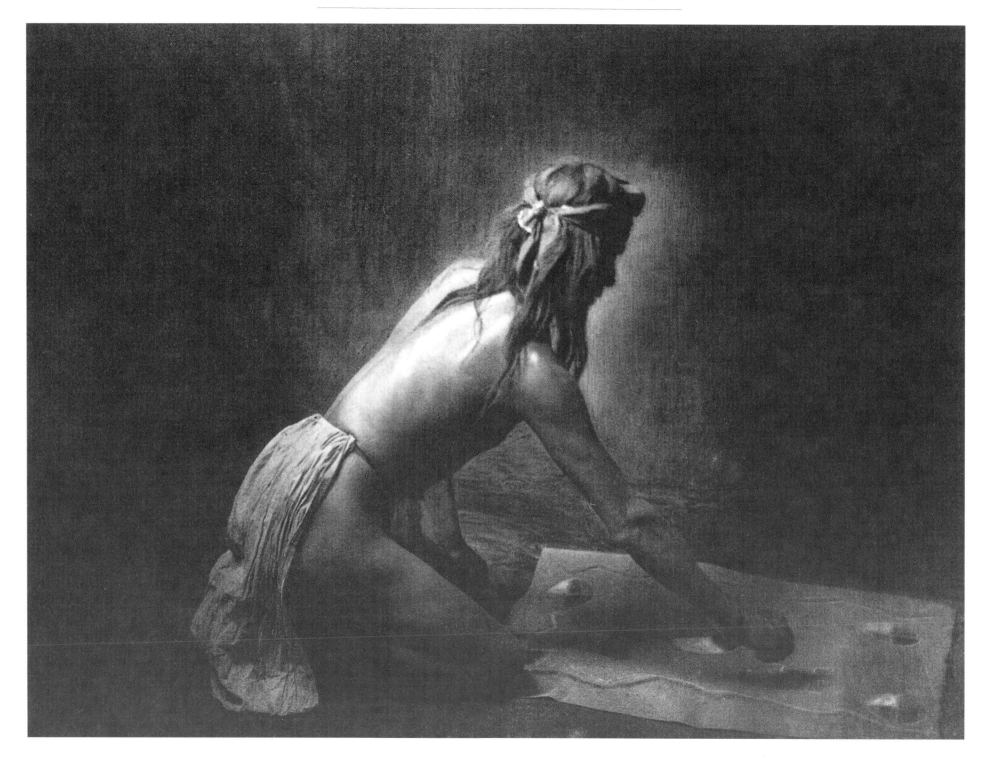

OPPOSITE:

Apache Medicine-Man, copyright 1907

Dark tonalities render the medicine man mysterious in this image. Curtis said: "The medicine-men of the Apache are most influential personages. They are usually men of more than ordinary ability, claiming, through their many deities and their knowledge of the occult and the ominous, to have supernatural power."

ABOVE:

The Morning Bath, Apache, copyright 1906

This very painterly image also has an air of mystery. Carefully manipulated highlights and shadows draw attention to the arch of the bather's back while making a silhouette of the face.

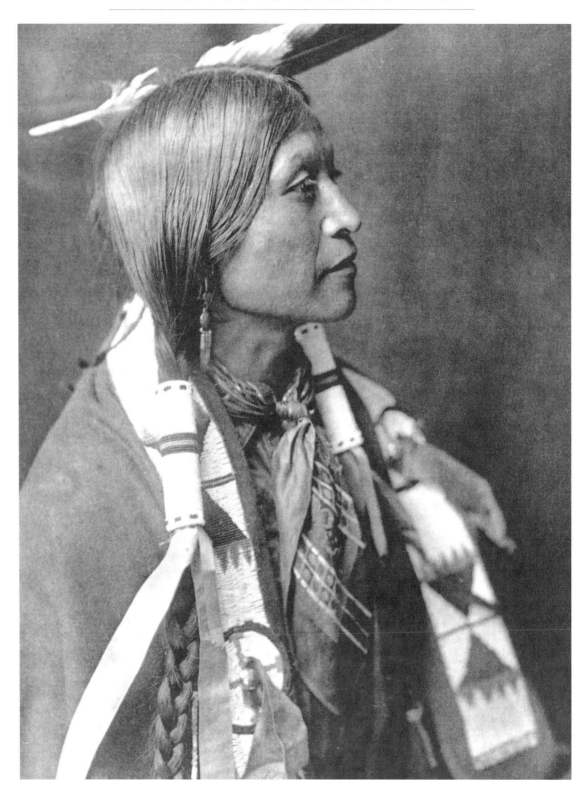

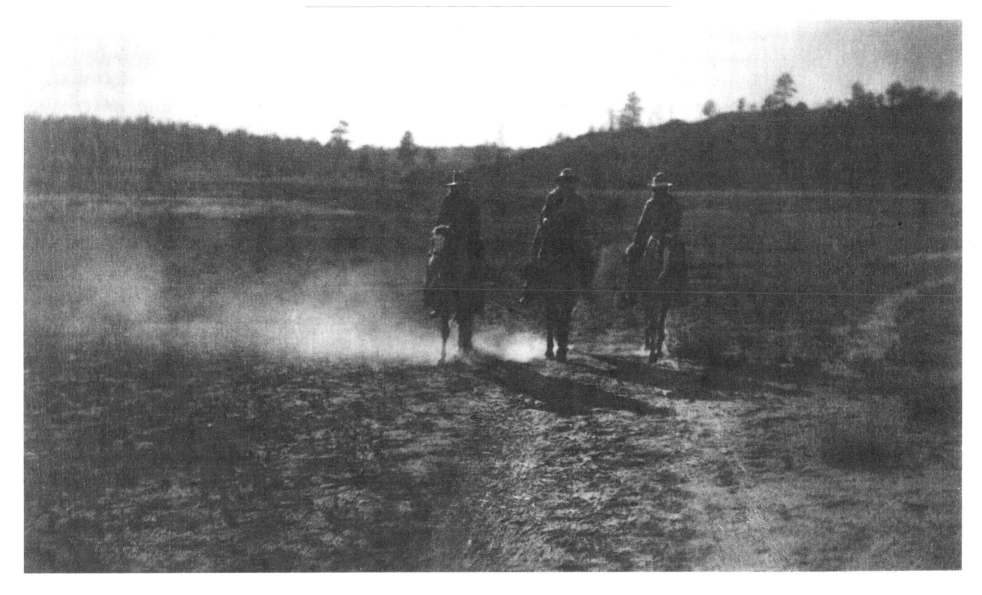

OPPOSITE:
A *Jicarilla,* copyright 1904

Curtis wanted to show the "old ways" of Native Americans by photographing them in traditional costume. However, blue jeans were the current style, so he had to request that they wear traditional costume. Sometimes he would have to pay to have costumes made for subjects who did not own traditional clothing.

ABOVE:
Jicarillas, copyright 1904

In contrast to *The Vanishing Race,* the subjects of this image are coming toward the viewer. They are still shadowy figures on horseback, but they are bathed in a raking light beneath a sunlit sky. Perhaps Curtis is saying that theirs is an uncertain but more hopeful future.

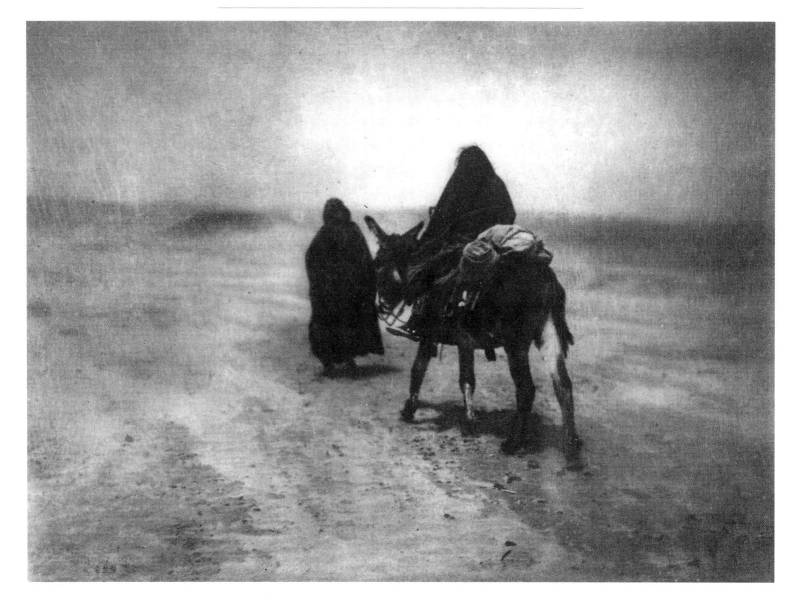

ABOVE:
Into the Desert, Navaho, copyright 1904

This image resembles archetypal religious paintings of The Flight Into Egypt, in which Joseph and Mary flee Bethlehem after the birth of Jesus when Herod ordered that all babies in the vicinity around Bethlehem be put to death, in an attempt to ensure the elimination of the child whom the Magi had called the King of the Jews. Here art certainly took precedence over ethnography.

OPPOSITE:
Canyon de Chelly, Navaho, copyright 1904

Struck by the long history of the region, Curtis was moved to reflect upon the contrast between the layers of history seen in the monumental rock formation and the passing of the Navaho from the scene. The image suggests a return to the theme announced in *The Vanishing Race*.

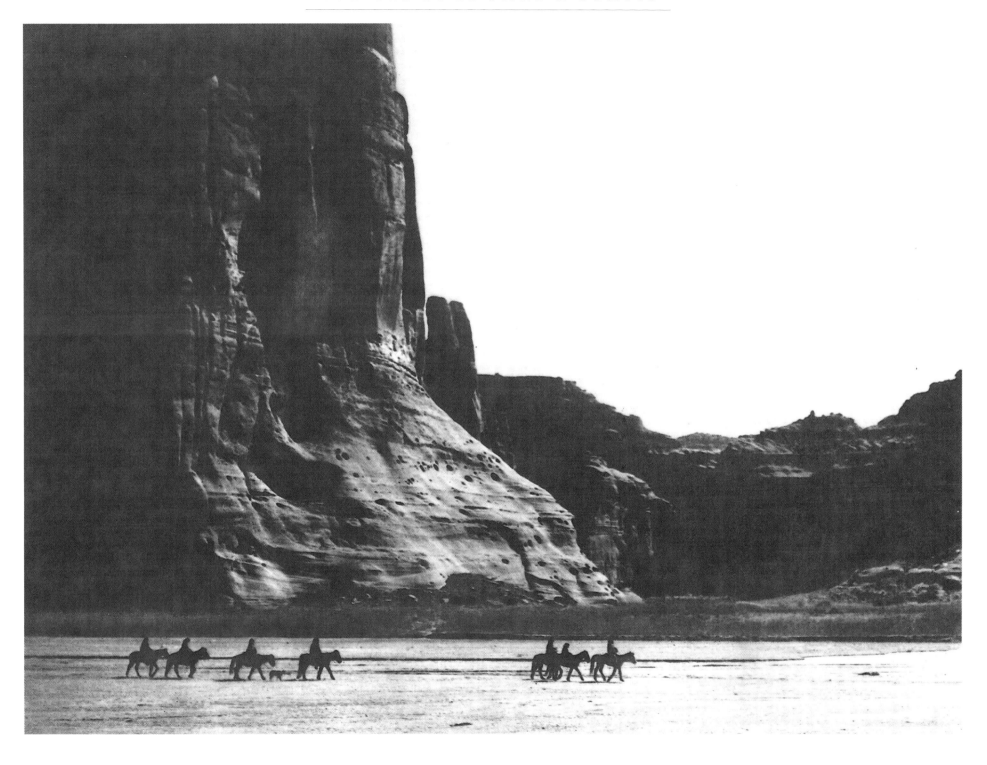

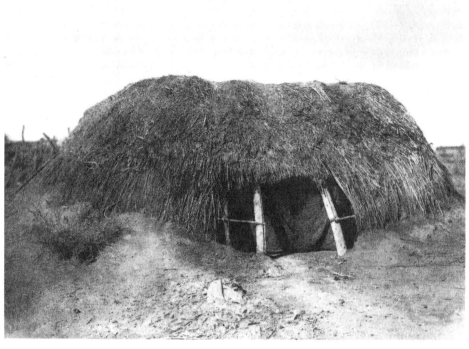

ABOVE:

Author's Camp, Walapai-land, copyright 1907

Curtis generally spent the winter months presenting exhibitions, giving lectures, and pursuing other activities which would raise funds to continue his project. However, on some occasions he was in the field during the winter.

ABOVE:

Ceremonial Ki, Pima, copyright 1907

Simple shapes such as this mound shelter were pictorially appealing to Curtis. He observed that there was no smoke hole in the top of the structure because only small fires were needed in the warm climate of the region.

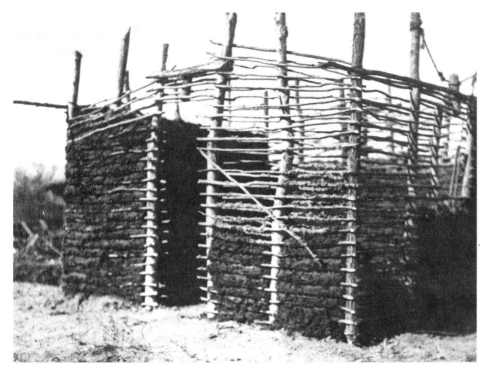

ABOVE:

Mojave Home Construction, copyright 1907

The soft focus typical of pictorial photographs was not so successful for images intended more for ethnographic purposes, such as this one. A clear and sharp picture would have been more scientific and revealing. Curtis was a much better pictorial than ethnographic photographer.

RIGHT:

Havasupai Cliff Dwelling, copyright 1903

Design was always one of Curtis's special talents, and this image is a good example of his style. The Havasupai woman balances the shadows, while the drapery of her dress brings one's eye back into the center of the image.

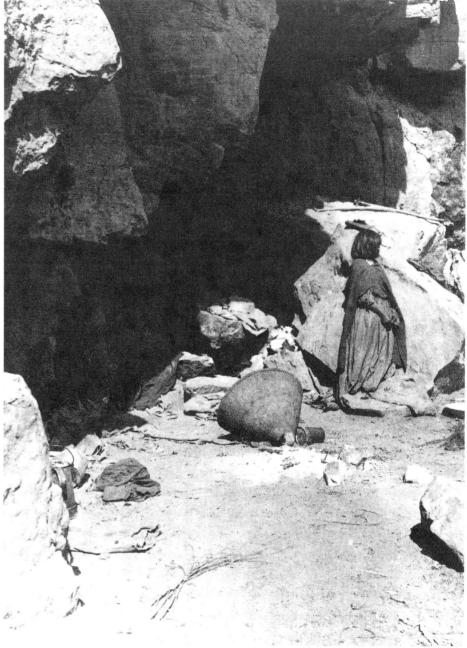

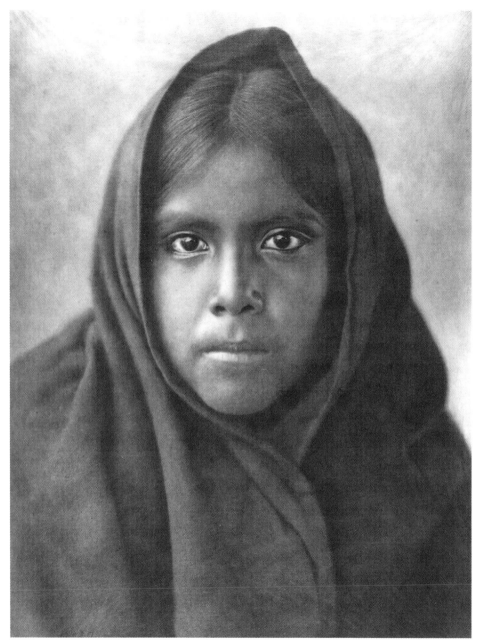

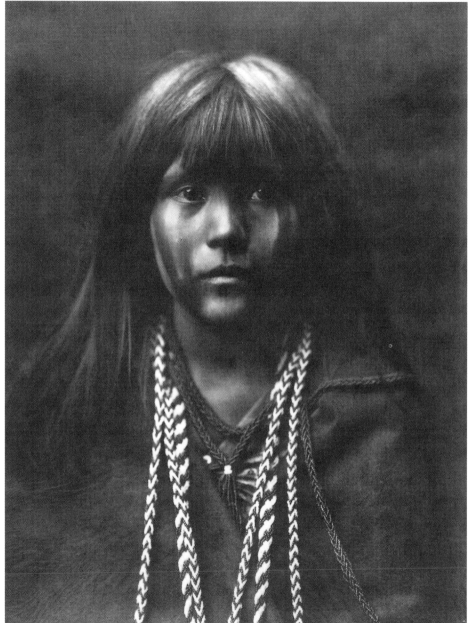

Pima Girl, copyright 1907

Curtis often selected his subjects for their attractiveness to him, but also for their interest as "types." He would occasionally apply ideas about ethnography learned from George Bird Grinnell and others to making pictures.

OPPOSITE RIGHT:
Mosa, Mohave, copyright 1903

This image must have been particularly touching to Curtis, because he said: "Her eyes are those of the fawn in the forest, questioning the strange things of civilization upon which it [sic] gazes for the first time."

RIGHT:
The Yuma, copyright 1907

Often the ratio of highlight to shadow in Curtis's portraits is more theatrical than photographic. Theatrical lighting tends to have greater contrast, creating drama rather than dwelling on detail.

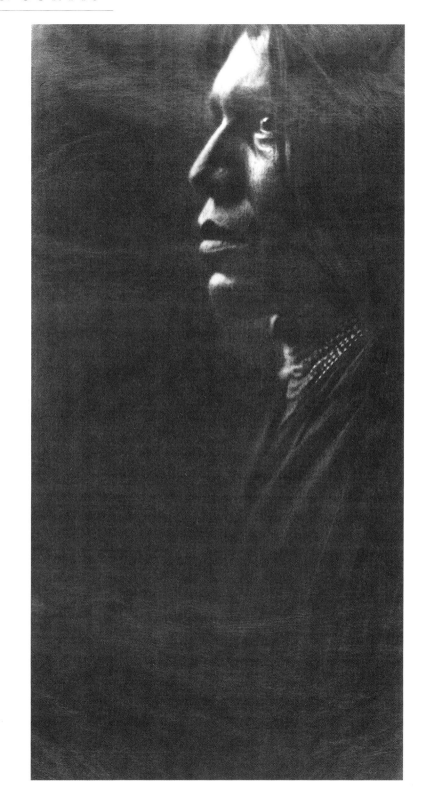

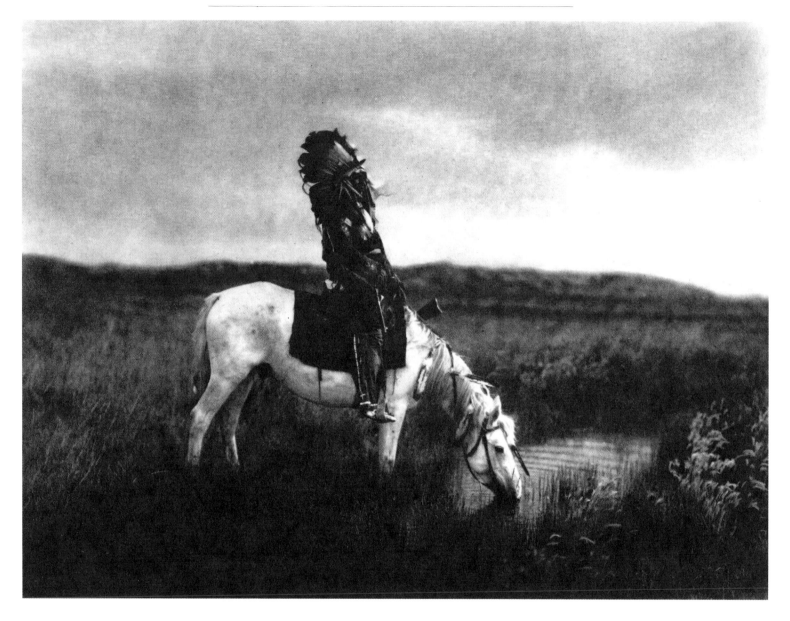

ABOVE:

An Oasis in the Badlands, 1905, copyright 1905

Escorted by 20 Sioux, Curtis photographed Chief Red Hawk in the Badlands near Wounded Knee. He then offered to give a feast on his next visit so he could make photographs of the group reenacting ancient rites and customs. Upon his return in 1907, not 20 but 300 Sioux were waiting to be photographed and given a feast.

OPPOSITE:

Ogalala War-Party, copyright 1907

Traditionally, Sioux warriors were considered fierce, and Curtis's photographs reinforced that view. Curtis said of this image: "Many hold...mere sticks adorned with eagle-feathers or scalps...desiring to win honor by striking a harmless blow...as well as to inflict injury with arrow or bullet."

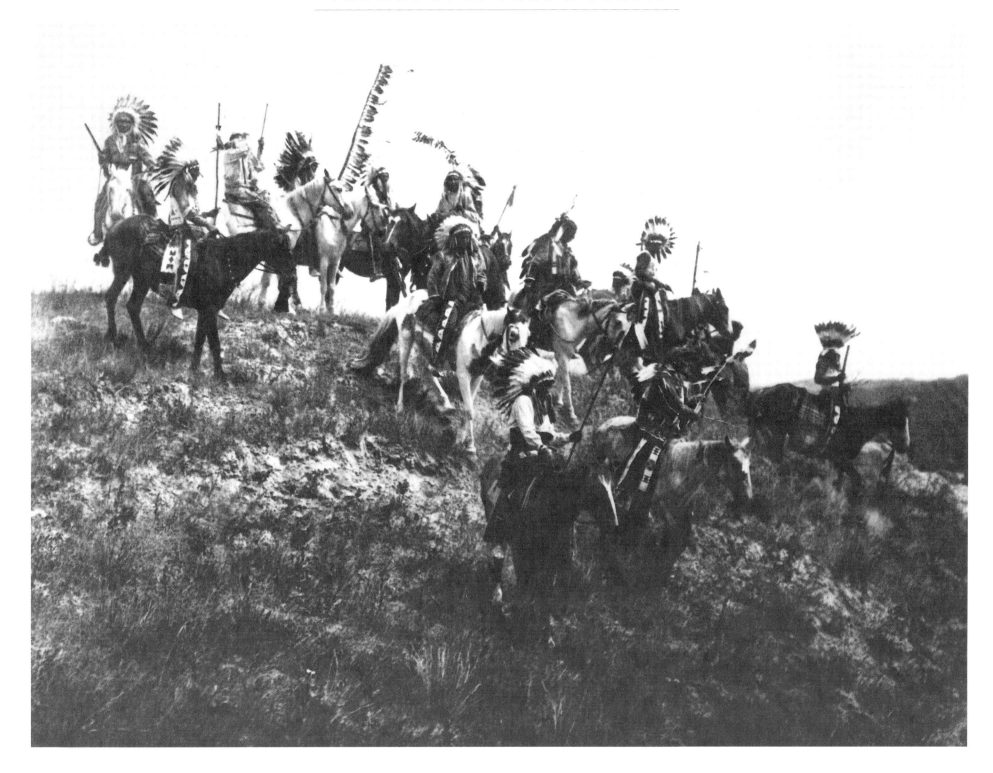

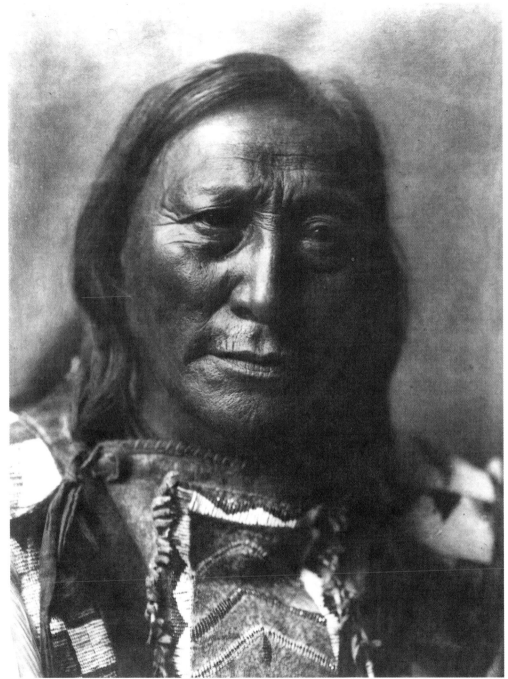

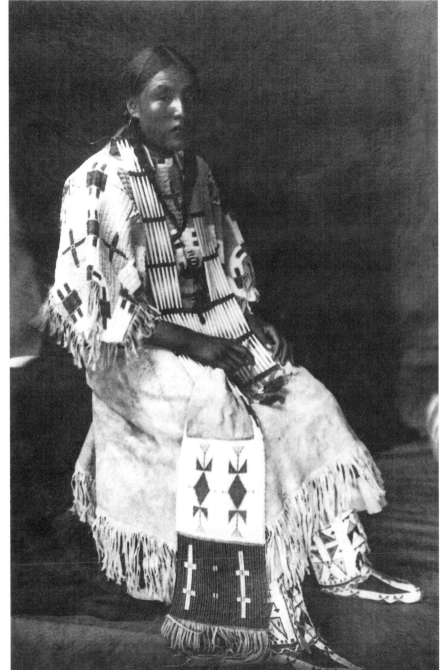

OPPOSITE LEFT:
Hollow Horn Bear, copyright 1907

Curtis studied his subjects carefully, often learning their biographies during the photographic encounter. Hollow Horn Bear, named for his grandfather, was reputedly a fierce warrior, but Curtis saw him in a kindly light.

OPPOSITE RIGHT:
Sioux Girl, copyright 1907

Recording traditional costume and customs were strong interests Curtis had in photographing Native Americans. He wanted to recreate the "old ways" as much as possible in his photographs.

RIGHT:
Prayer to the Mystery, copyright 1907

A Native American once highly complimented Curtis by saying that Curtis understood the Great Mystery. In this image, a pipe is offered aloft in supplication to the Mystery. A buffalo skull, symbolizing the spirit of the animal upon which so many Plains Indians depended, rests at the feet of the worshipper.

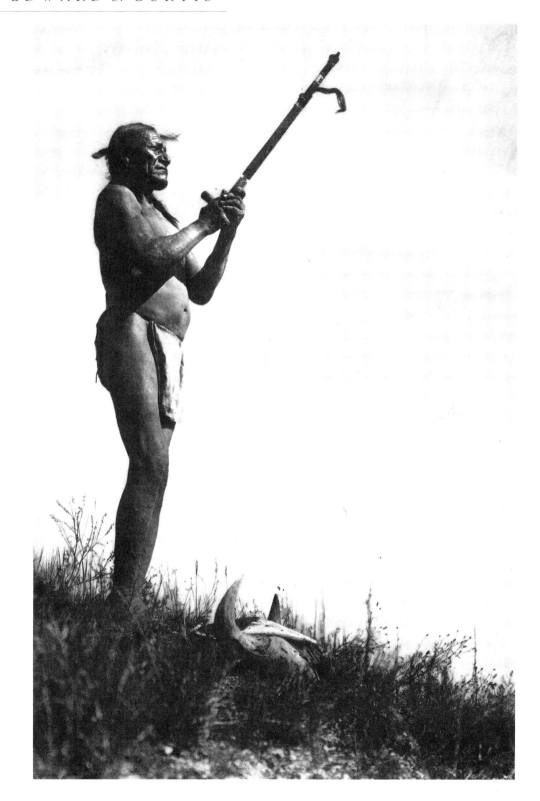

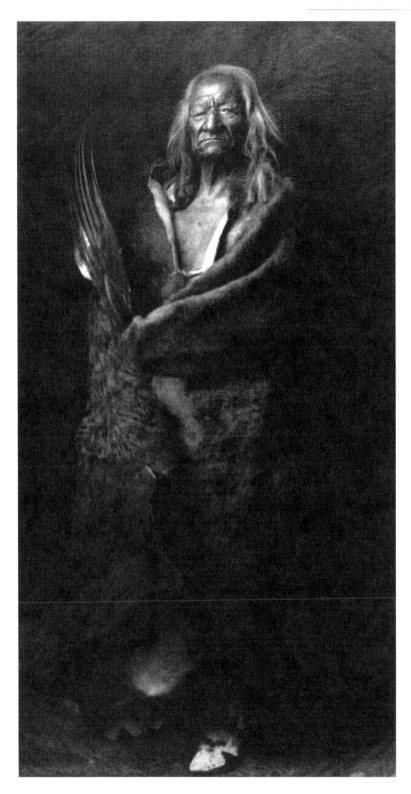

LEFT:

Black Eagle, Assiniboin, copyright 1908

Curtis learned the point of view of Native Americans, and won respect from them. His reputation spread from tribe to tribe, and many sought to be included in his project. Black Eagle, for example, was at first hostile, then came to Curtis's tent late one night and agreed to cooperate.

OPPOSITE LEFT:

Red Cloud, Ogalala, copyright 1905

Red Cloud became famous for his victories over the U.S. government by forcing the abandonment of three forts in the Powder River region (Wyoming) in a treaty signed in 1868. He was about 83 and blind when Curtis photographed him.

OPPOSITE RIGHT:

American Horse, Ogalala, copyright 1908

Traditional costume appealed to Curtis, who aspired to making images that showed Native Americans as they would have appeared before contact with Europeans.

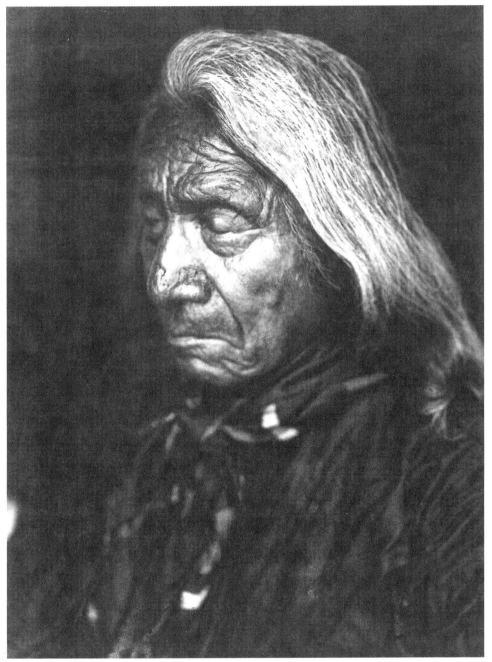

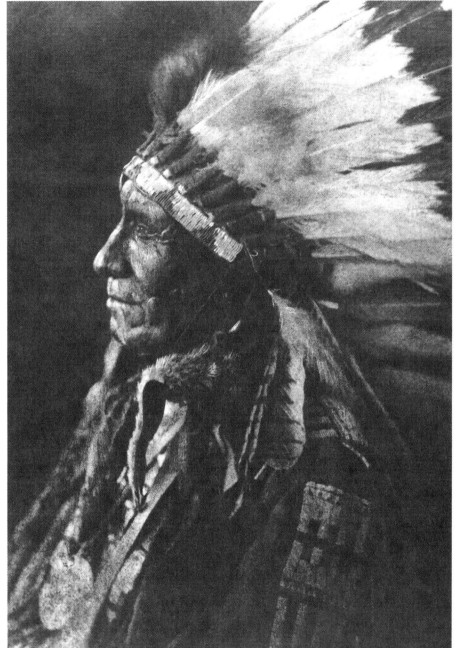

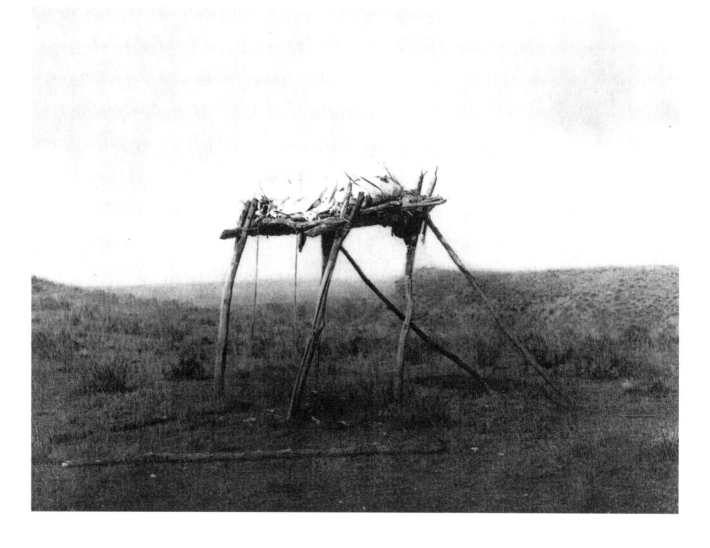

ABOVE:
A Burial Platform, Apsaroke, copyright 1908

This image, one of the most painterly by Curtis, possesses a presence usually found only in landscape painting. A relatively level horizon is broken only by the supports of the platform, the center of attention.

OPPOSITE LEFT:
"For Strength and Visions," copyright 1908

Curtis greatly respected the strength and endurance of Native Americans, qualities required for many of their rites. In this image, nonetheless, he did not focus upon the pierced flesh, but rather on the visual balance between the man and the tree branch.

OPPOSITE RIGHT:
The Eagle Catcher, copyright 1908

Aerial perspective and graphic quality are artfully combined in this image. The hazy background gives a kind of diorama effect to the image, while the sharp graphic shape of the subject separates him from the background. Eagles were considered sacred, and people who could catch them were deemed powerful.

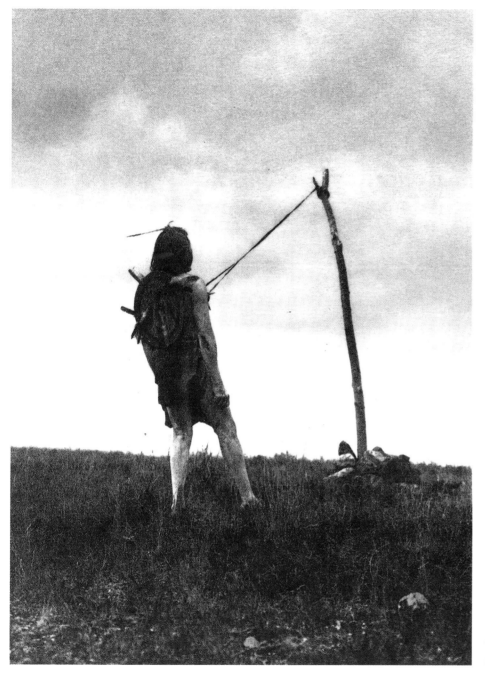

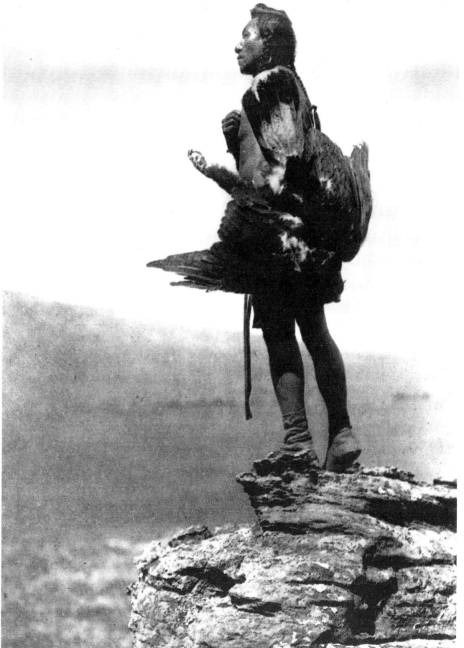

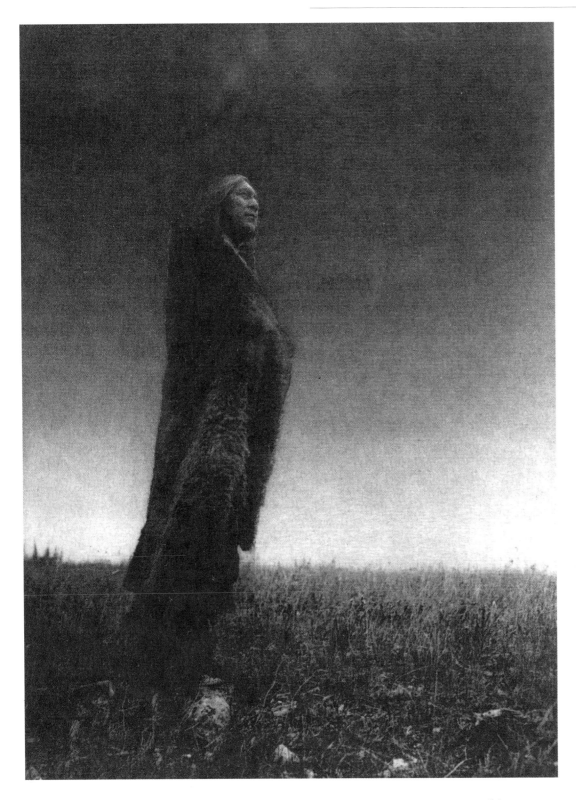

LEFT:
"Crying to the Spirits," copyright 1908

This image was quite unremarkable before Curtis applied his artistic skills. The figure was merely a silhouette against a light gray sky. By adding a gradation of tones to the sky, lightening the face, and diminishing details in the contours, tremendous drama was brought to the image.

OPPOSITE:
Mother and Child, Apsaroke, copyright 1908

Although not religious, Curtis was knowledgeable about religion. In this image he evoked the "Madonna and Child" theme. He was also probably expressing a longing for his own family, which he did not see often during the many years of field work.

OPPOSITE:

On the Little Bighorn, Apsaroke, copyright 1908

Curtis chose tranquil beauty to symbolize events which occurred nearby more than 30 years earlier, at the Battle of Little Bighorn. Native Americans call those events The War for the Black Hills, while Euro-Americans often refer to them as Custer's Last Stand.

RIGHT:

Bear's Belly, Arikara, copyright 1908

Curtis carefully illuminated scars on the chest of Bear's Belly, who at 19 became a scout for Custer. Foretelling the future, a medicine man took sections of skin and made an offering for protection. A member of the spiritual fraternity of Bears (beset by three bears, he had killed them all), he wears a bearskin in Curtis's photograph.

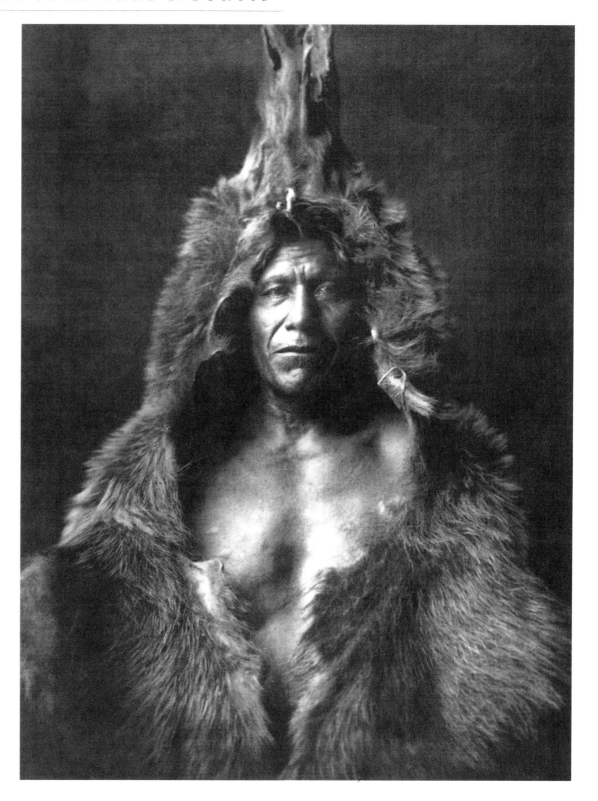

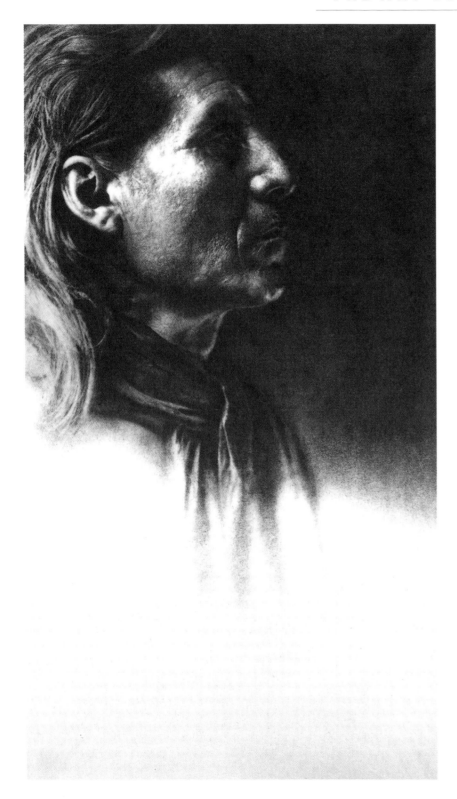

LEFT:

Little Sioux, Arikara, copyright 1908

Somewhat daring in approach, this image looks like an unfinished sketch, a characteristic enhanced by the image having been dodged out on the lower portion and by the positioning of the subject tightly into the top left-hand corner.

OPPOSITE:

On the War-Path, Atsina, copyright 1908

Pictorialists tended to make conventional images. Curtis was more inventive than most, and had tribes of Native Americans as actors in his stereotypical images. He could even ask them to make believe they were on the warpath, such as in this image.

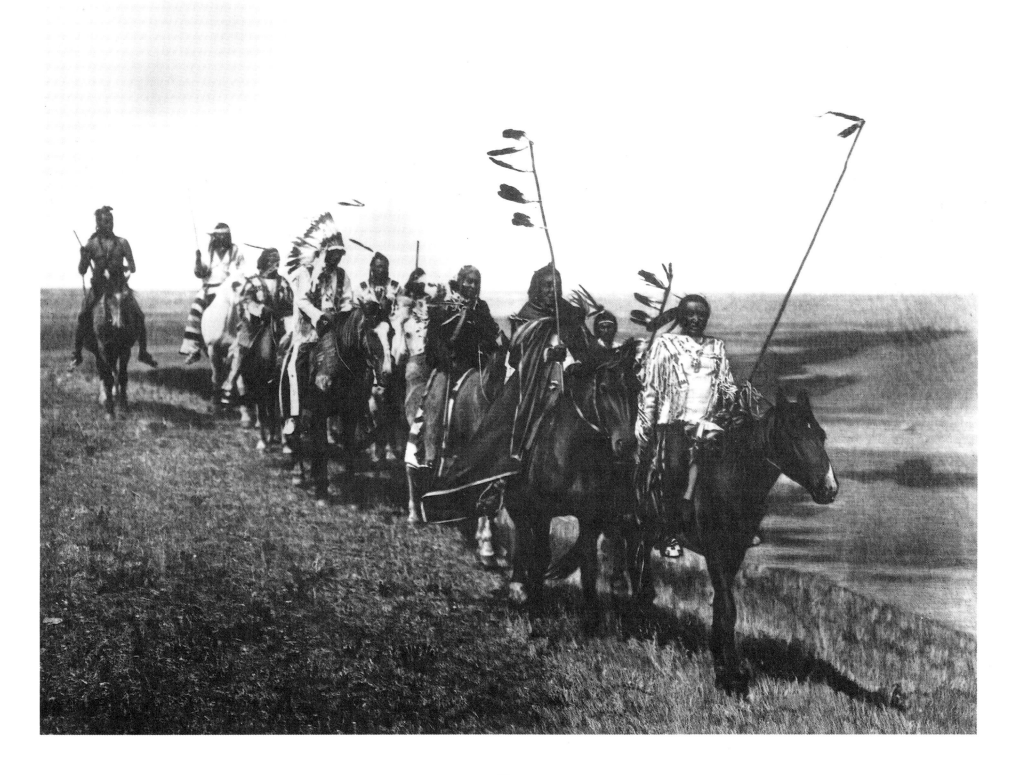

ABOVE:
The Sacred Turtles, Mandan, copyright 1908

The Sacred Turtles were drums made of buffalo hide which
purportedly held the spirits of buffalos. Photographing them was,
Curtis related, a triumph, since only tribe members had ever seen
them. Curtis said he paid an unscrupulous medicine man $500 to get
access to them.

RIGHT:
"Beside the Stream," copyright 1908

Far from reporting facts about aquiculture or the daily life of a maiden, this image shows a beautifully adorned young woman posing for the camera at a stream. Curtis could hardly have done better at creating a pictorial arrangement of a figure in nature.

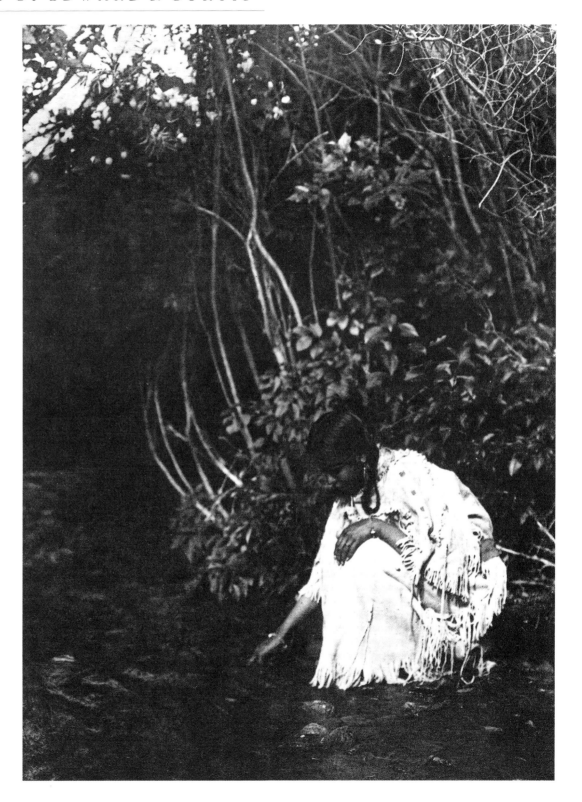

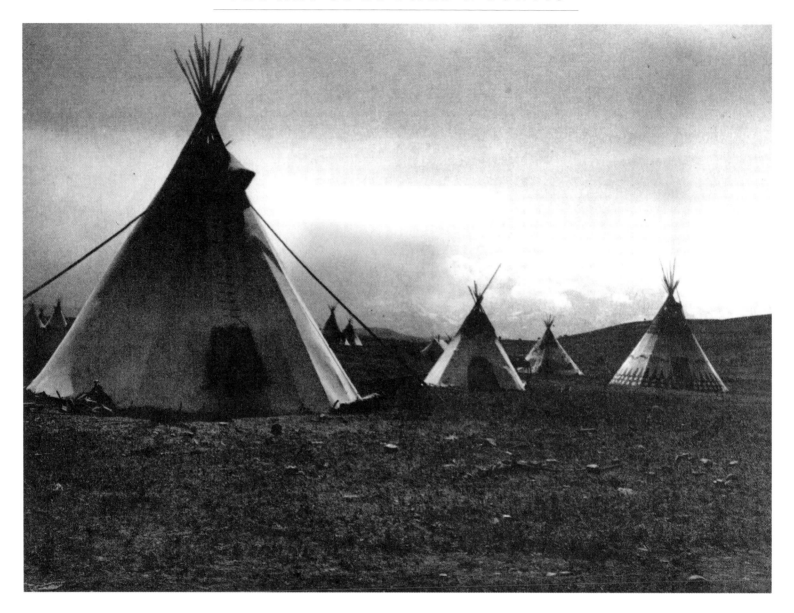

ABOVE:

Camp in the Foothills, Piegan, copyright 1905

Similar to other images he made, Curtis manipulated the sky to add drama to this image. The stillness gives a feeling of mystery, a quality he surely sought.

OPPOSITE:

A Piegan Home, copyright 1910

Although Curtis's avowed purpose was to show the old ways, he gave recognition to the changes that were occurring. Here he depicts the old and new styles of Piegan housing.

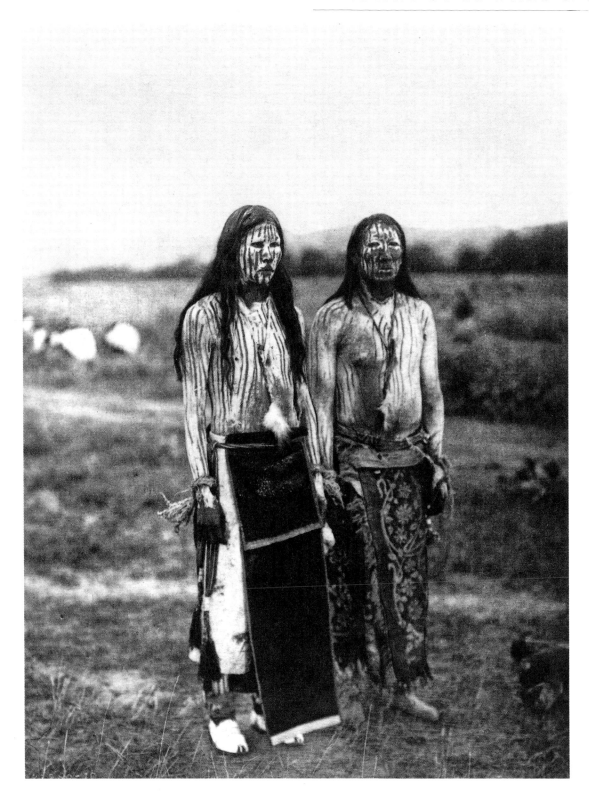

LEFT:

Sun Dance Pledgers, Cheyenne, copyright 1911

Curtis was afforded unusual access to rituals and ceremonies such as the Sun Dance. A feature of the Sun Dance was that a vow or pledge was made in exchange for warding off sickness or other difficulties. Pledgers adorned themselves in preparation for the ritual.

OPPOSITE:

In a Piegan Lodge, copyright 1910

Although this is not Curtis's most gracefully arranged image, it still is a distinctive portrait of Little Plume with his son, Yellow Kidney. True to traditional representation, Curtis retouched the image to remove what might have been a clock by the right arm of the older man.

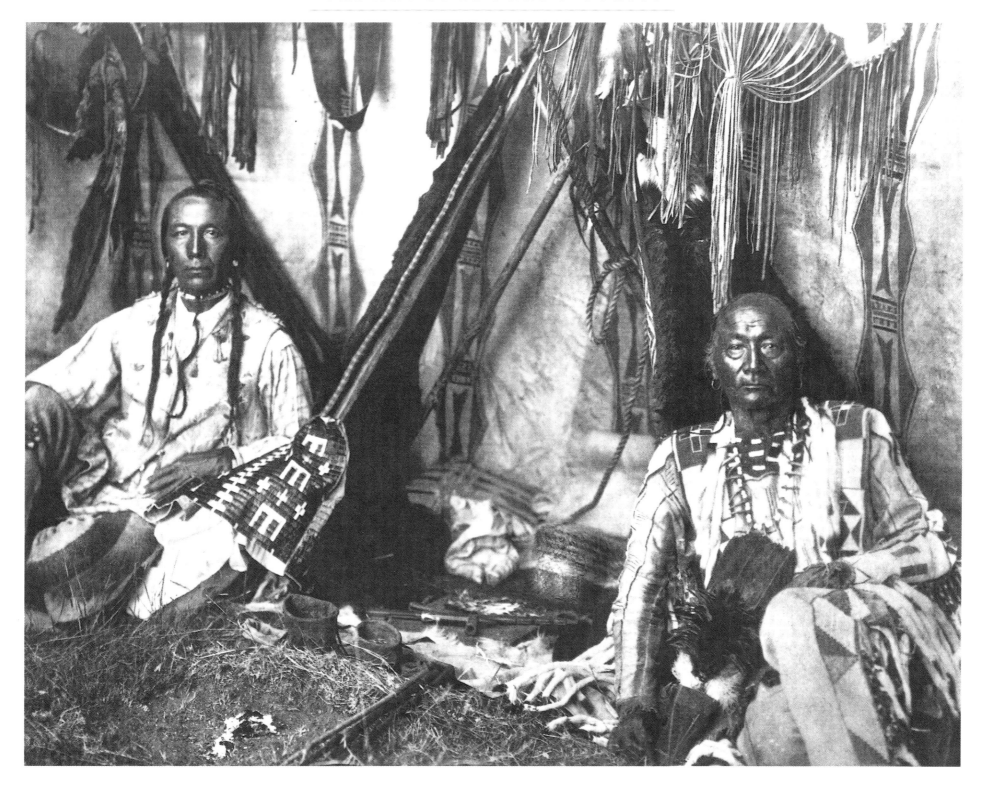

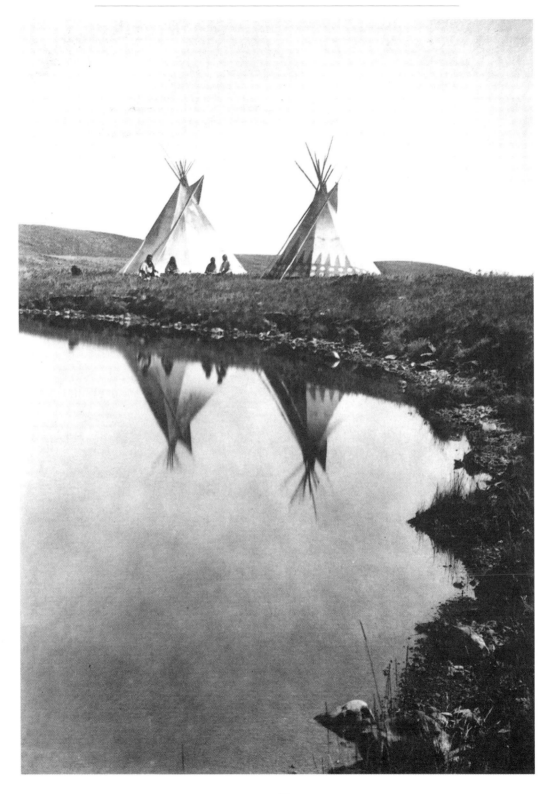

OPPOSITE:

At the Water's Edge, Piegan, copyright 1910

The triangular shape of the lodges is repeated throughout this image, including in the reflections in the water and the way the embankment juts into the lake. It appears that Curtis was enamored of the shape, and sought to repeat it several times in this charming image.

RIGHT:

Gambler, Piegan, copyright 1900

It was undoubtedly a thrill for Curtis to make this image. All of the props he would have considered requisite were already present, including feathers, beads and braids. He often reveled in the accoutrements of Native Americans in his photographs.

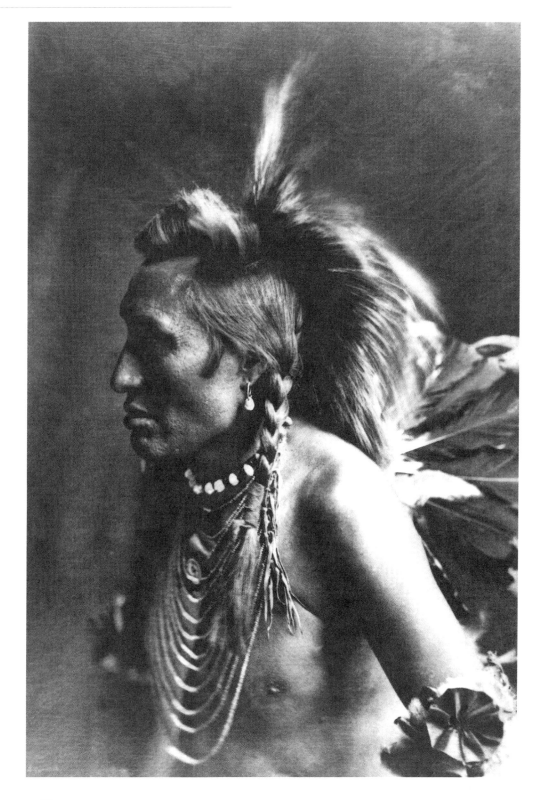

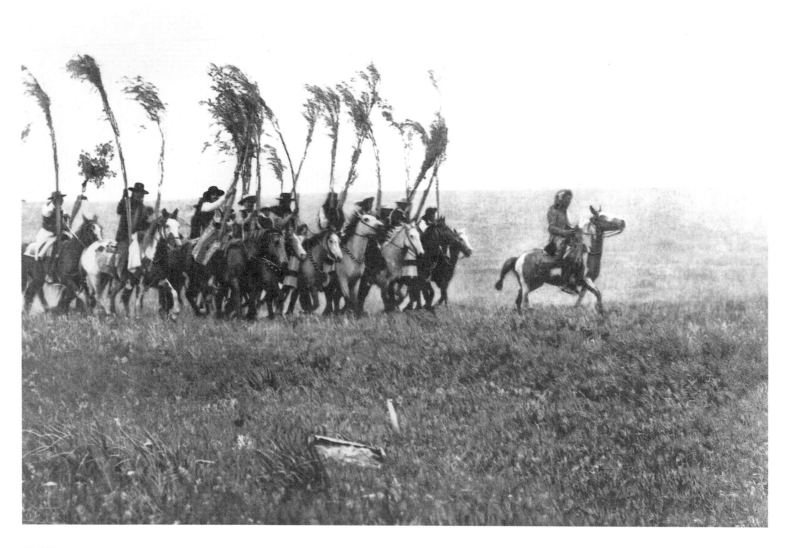

ABOVE:

Bringing the Sweat-Lodge Willows, Piegan, copyright 1900

Young horsemen brought the pliant willow rods which would be stuck in the ground and fastened into a framework to be covered with blankets or skins. Heated stones were placed in a hole dug near the door to create dry heat or steam for the occupants. On this occasion, such baths were associated with the rituals of the Sun Dance.

OPPOSITE:

Piegan Encampment, copyright 1900

Curtis said of this image: "The picture presents a characteristic view of an Indian camp on an uneventful day, but also emphasizes the grand picturesqueness of the environment of the Piegan, living as they do almost under the shadow of the towering Rocky Mountains."

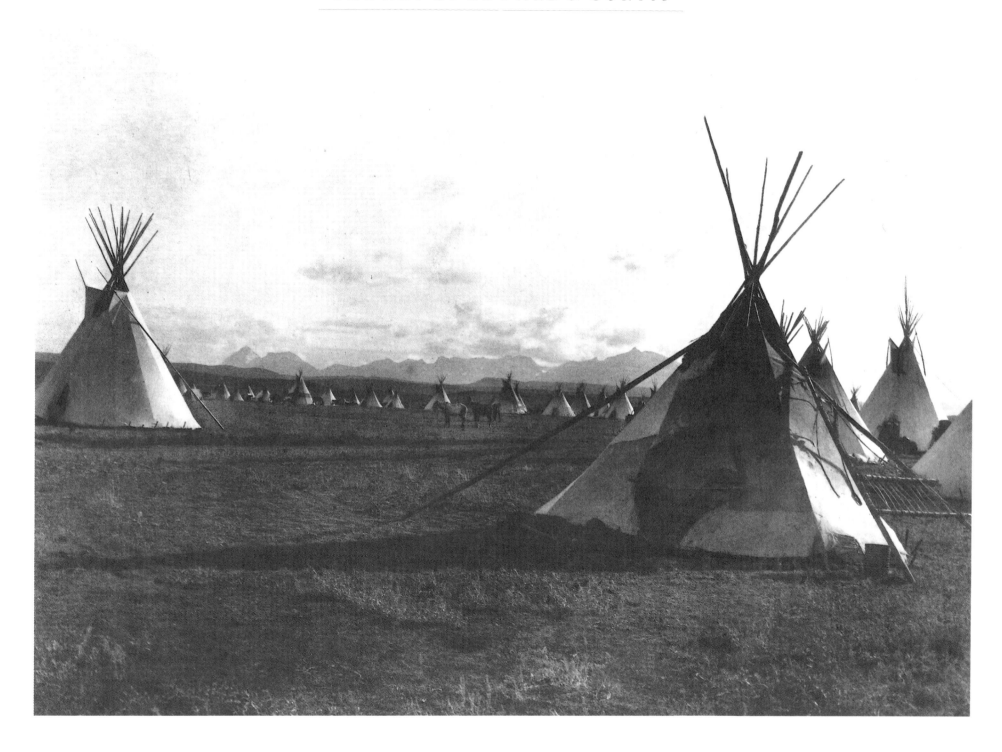

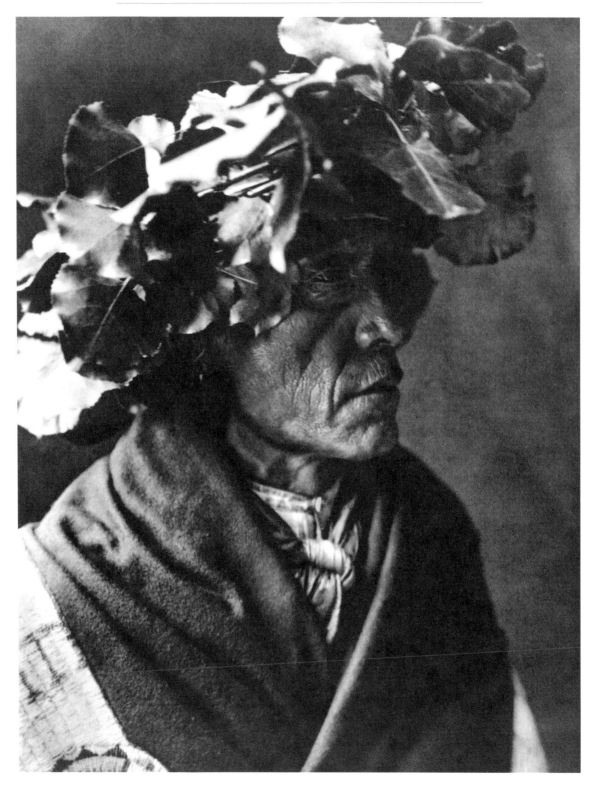

OPPOSITE:

Porcupine, Cheyenne, copyright 1910

Making a formal portrait of a man with a thatch of cottonwood leaves on his head was one way Curtis could show that Native Americans lived close to nature. In context, rather than in a portable studio, such an image would be less unusual. The leaves were worn at summer gatherings, such as the Sun Dance, for protection against the sun.

RIGHT:

Two Moons, Cheyenne, copyright 1910

Proudly portrayed is Two Moons, one of the Cheyenne war chiefs at the Battle of Little Bighorn in 1876 where Custer and his troops were annihilated.

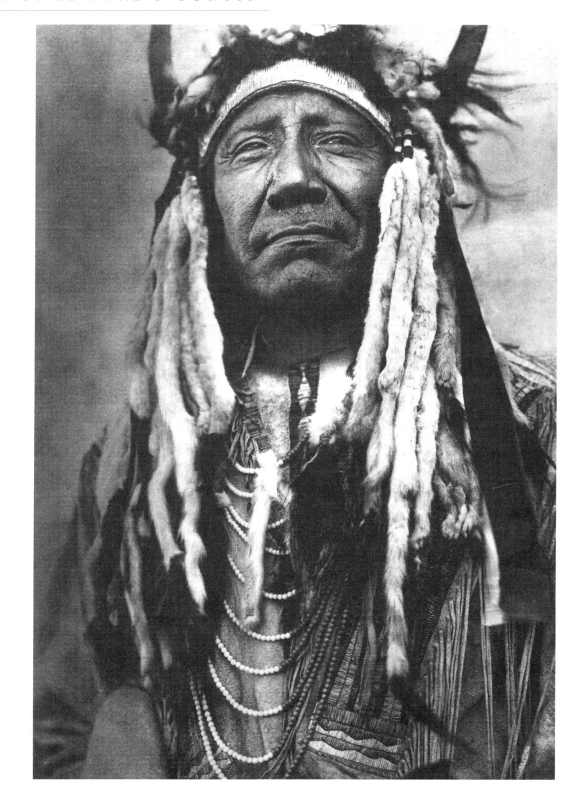

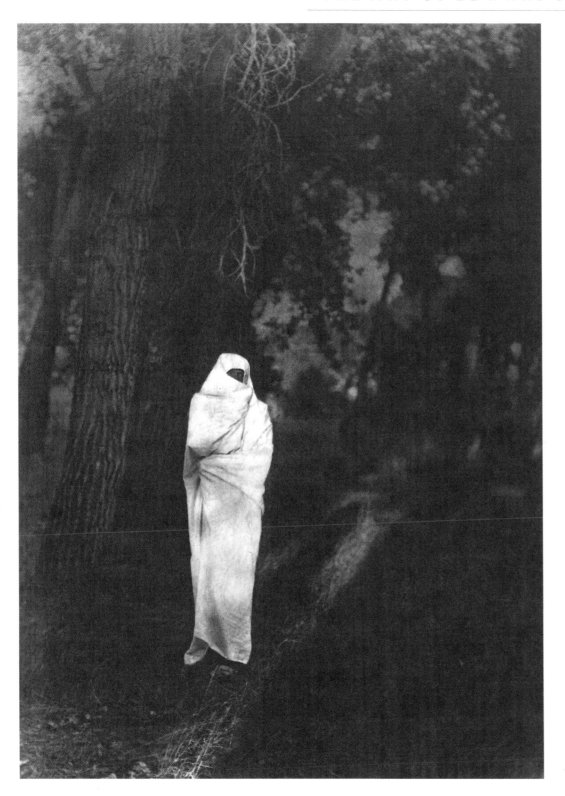

LEFT:

Waiting in the Forest, Cheyenne, copyright 1910

This mysterious figure seems almost to float in a dark space, Curtis's approximation of dusk. In large encampments, young men wrapped in cotton sheets were afforded anonymity while waiting for their sweethearts.

OPPOSITE:

Sons of a Yakima Chief, copyright 1910

Curtis undoubtedly liked the striped coverings of the lodge and floor; however, the image has little of the pictorial quality for which he often strived so hard.

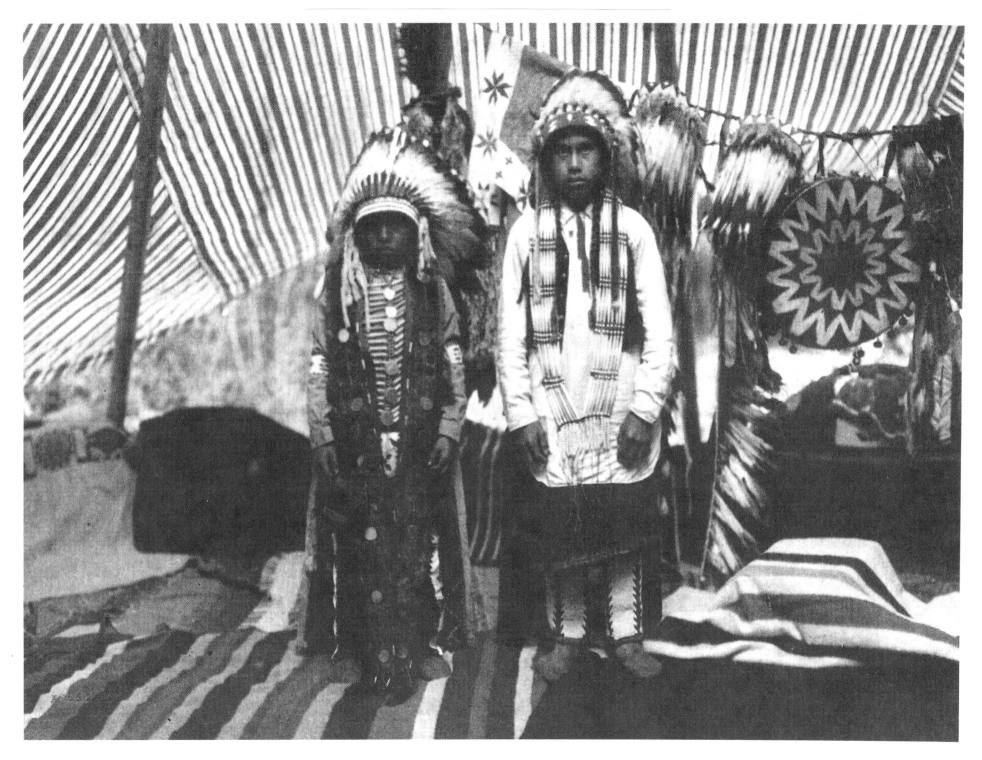

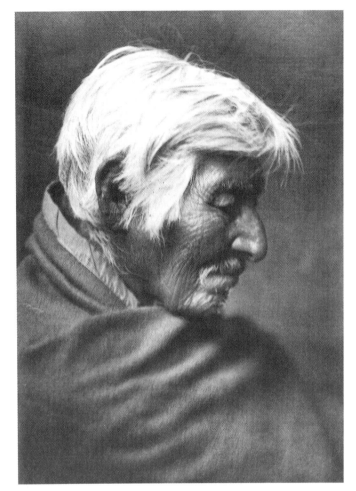

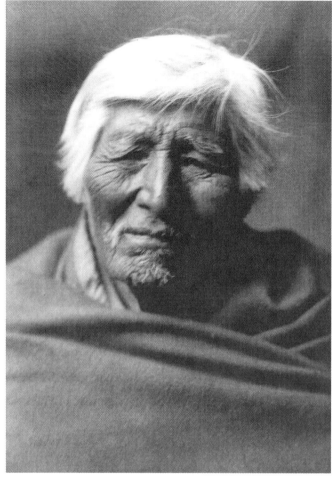

ABOVE:
Klickitat Profile, copyright 1910

Fears that advancing "civilization" was destroying variations among the races prompted the use of measuring devices and photography to record anthropometric data (body measurements). Full figure and head images, front and profile, allowed comparisons to be made. Curtis followed that lead and made anthropometrically inspired images.

ABOVE RIGHT:
Klickitat Type, copyright 1910

Curtis's use of anthropometry did not follow any of the established systems which employed measuring devices or gridded backgrounds. His approach was less scientific and, as might be expected, more pictorial. He did not seem to mind that the elderly man in this image could not hold his head still, resulting in a blurry image.

OPPOSITE LEFT:
Chief Joseph, Nez Percé, copyright 1903

Chief Joseph, folk hero and friend to Curtis, devoted his life to peace but was forced by circumstances to fight, in Curtis's words, "the greed of whites." Although the tribe wanted to remain in the Wallowa Valley, Oregon, the authorities insisted upon moving the tribe to Idaho in 1877. The outnumbered Nez Percé eventually lost the war.

OPPOSITE RIGHT:
Three Eagles, Nez Percé, copyright 1910

Three Eagles, relation to and confidant of Chief Joseph, told Curtis the story of the Nez Percé War. As in his portraits of Theodore Roosevelt and Chief Joseph, Curtis used chiaroscuro to represent Three Eagles with great respect.

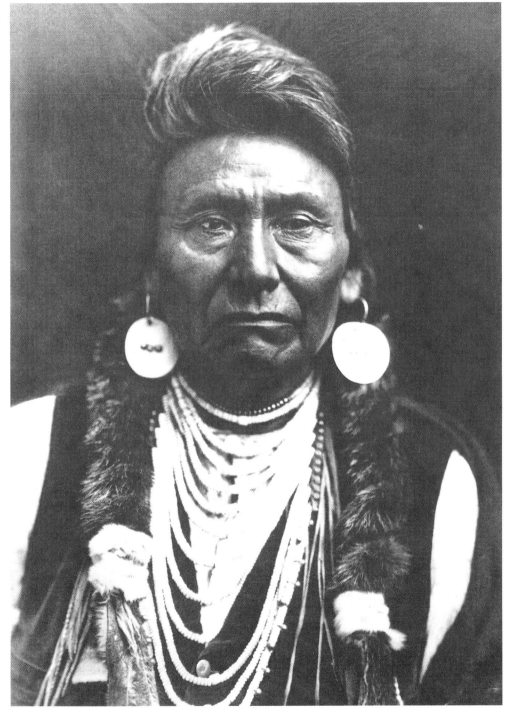
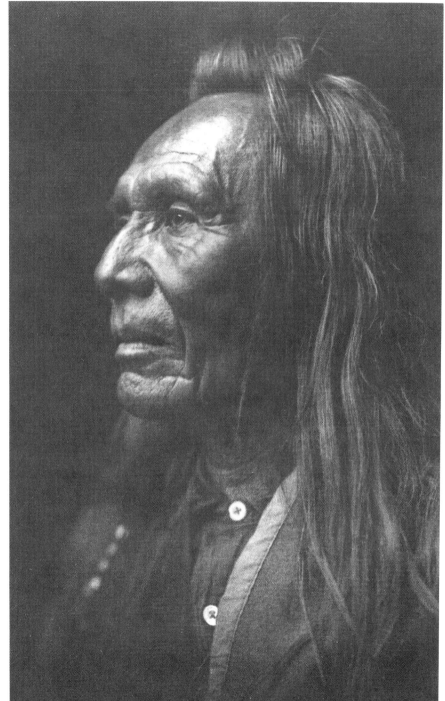

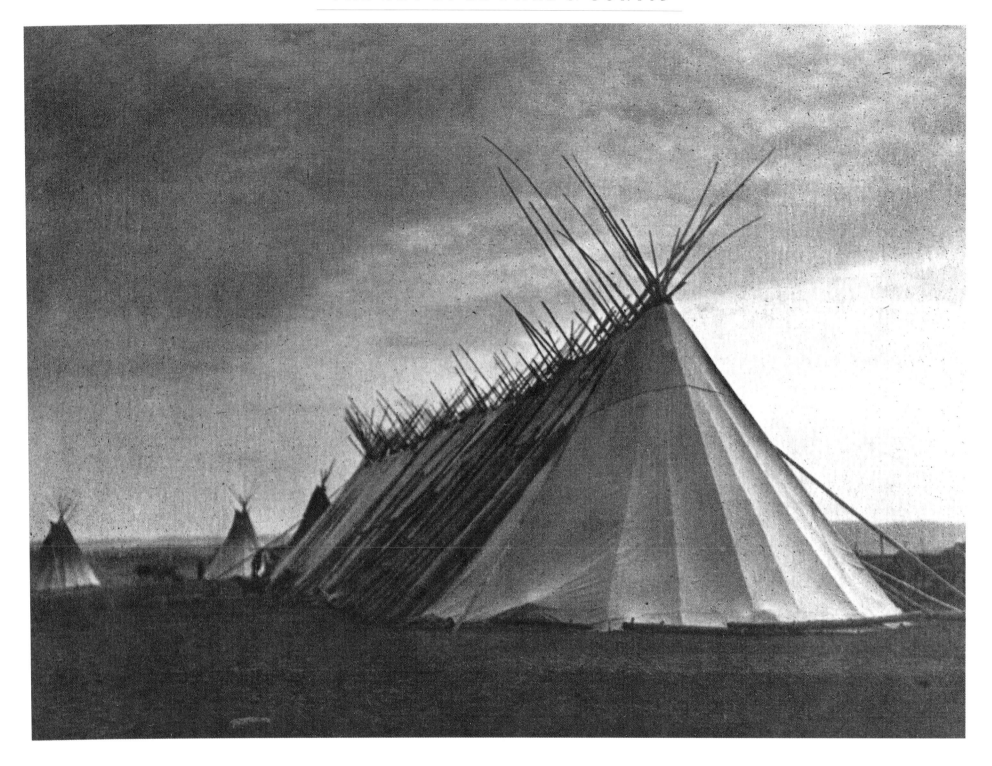

OPPOSITE:

Joseph Dead Feast Lodge, Nez Percé, 1905, copyright 1905

This painterly image depicts the largest lodge Three Eagles said he
had ever seen. The lodge, big enough to hold more than ten fires, was
built for a potlatch, to distribute the possessions of the deceased
Chief Joseph.

RIGHT:

A Young Umatilla, copyright 1910

The representation of a dashing and somewhat mysterious
appearance was typical of Curtis's style of portraiture, both in his
Seattle studio and in the field. Few portrait photographers were
willing to make such dramatic close-up images.

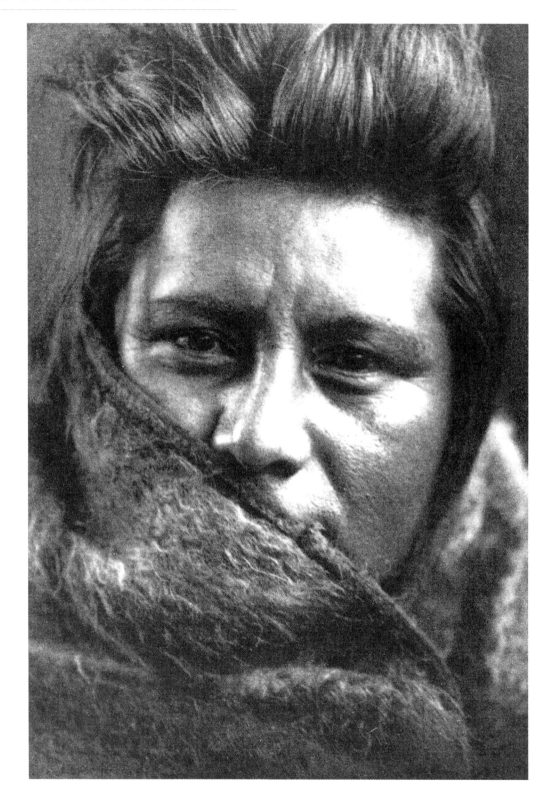

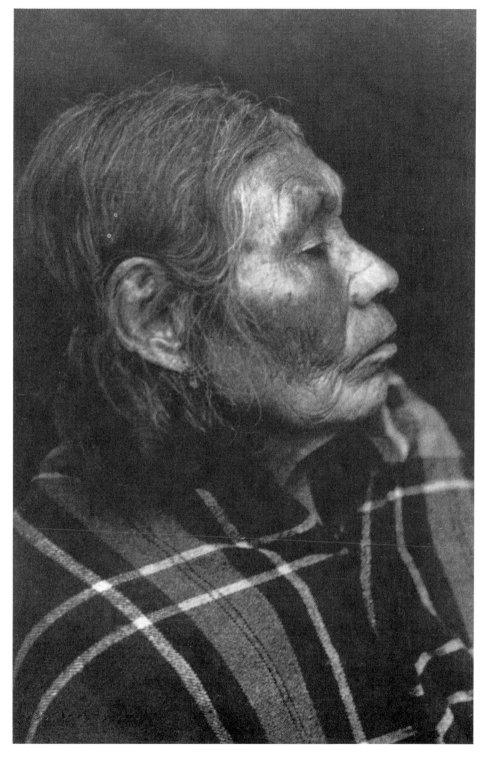

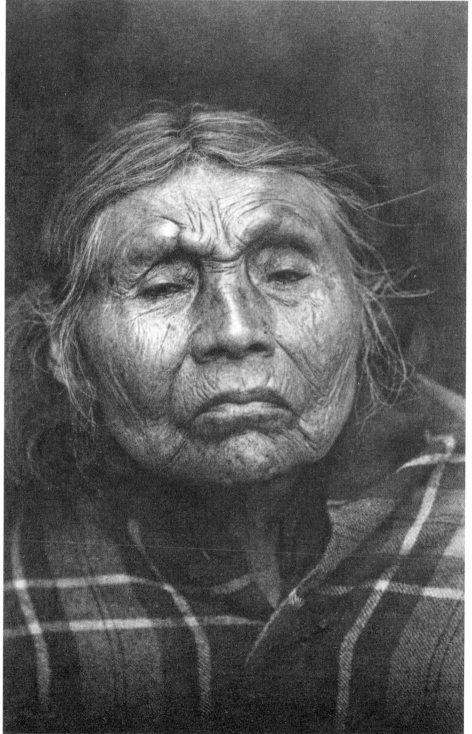

OPPOSITE LEFT:
Chinook Female Profile, copyright 1910

Using an anthropometrical approach again, Curtis still managed to make an interesting portrait not dominated by ethnographic concerns.

OPPOSITE RIGHT:
Chinook Female Type, copyright 1910

The look of experience and wisdom characterizes this portrait Curtis labeled a "type." He would not have dwelled upon a Seattle aristocrat's wrinkles as he has on those of this Chinook woman in this exceptionally powerful portrait.

RIGHT:
The Fisherman, Wishham, copyright 1909

The graceful lines of a Wishham man using a dip net to catch salmon was also an opportunity for Curtis to make a virtuoso pictorial image. As the river narrows, the eye is led to the man, then upstream.

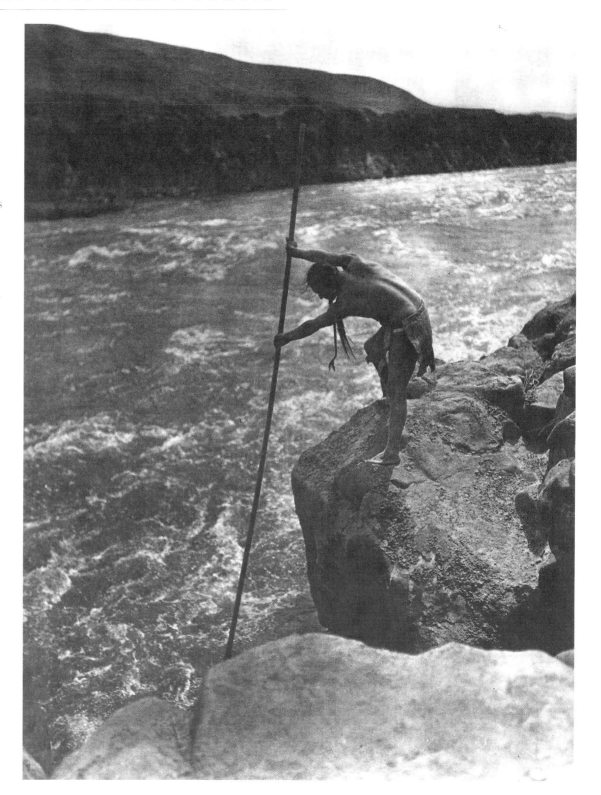

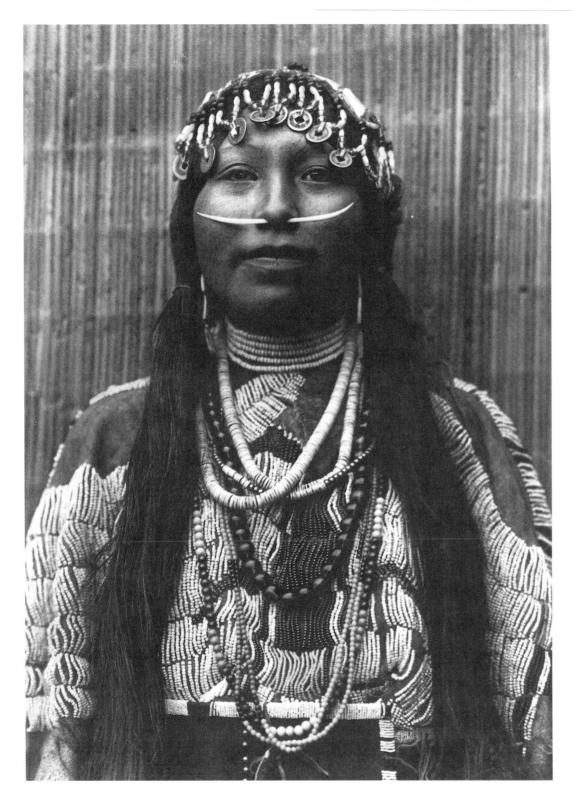

LEFT:

Wishham Girl, copyright 1910

The background of this portrait appears to be a stitched mat shelter; however, visually it resembles a gridded anthropometrical backdrop. The well-born Wishham typically wore a dentalium shell thrust through a perforation in the septum, a characteristic Curtis wanted to emphasize in this image.

OPPOSITE:

Shores of Puget Sound, copyright 1898

As the years of Curtis's grand endeavor passed, his imagery became less dominated by pictorialist aesthetics. This image made before the project got underway contrasts dramatically with others made at the time the image was published in 1913.

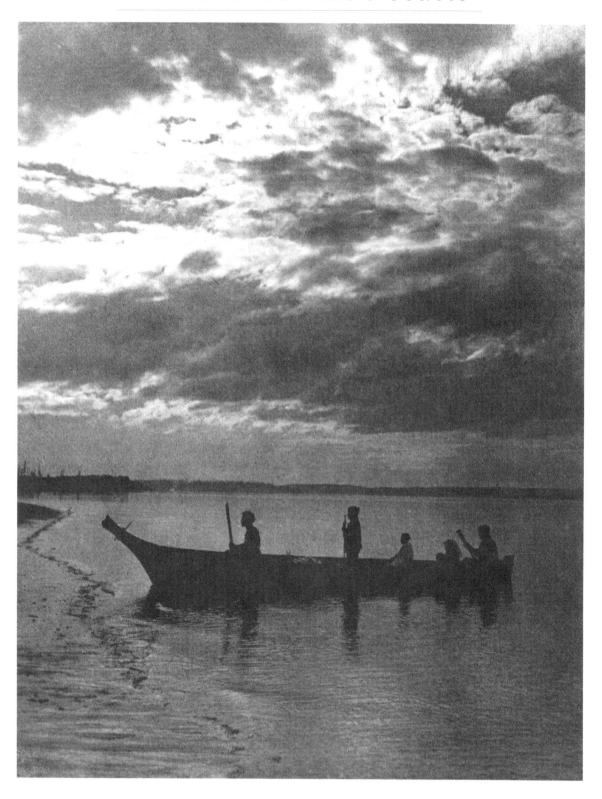

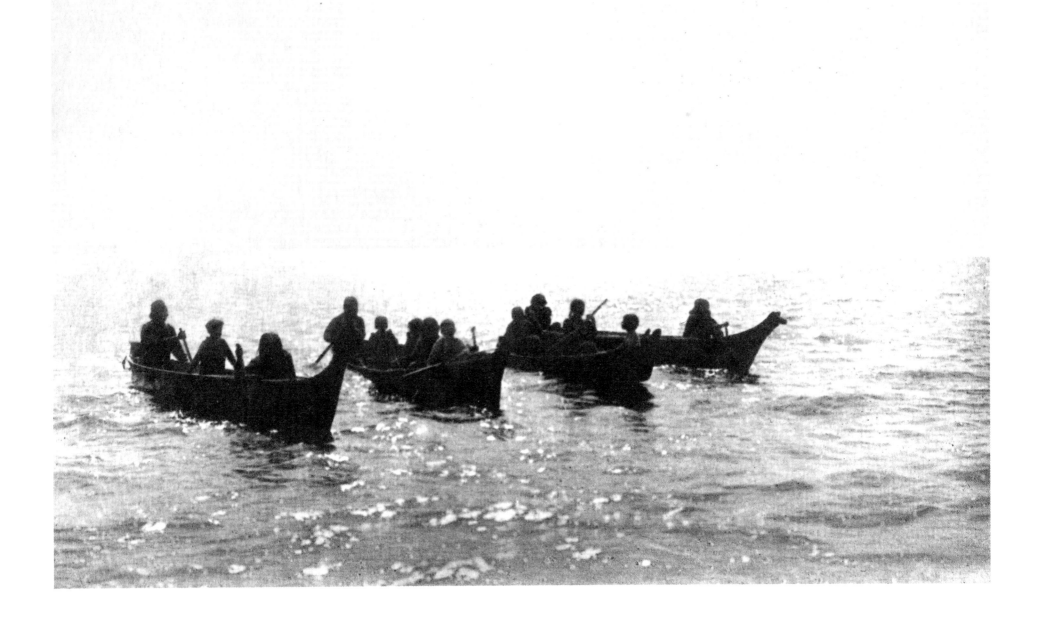

OPPOSITE:
On Shoalwater Bay, copyright 1912

Curtis was known to have used a motion picture camera from time to time between 1906 and 1913, when he began making a feature-length commercial film. It is not surprising that as he became more involved with film-making, his still photographs, such as this one, became more like movie stills.

RIGHT:
Tule Gatherers, copyright 1912

Aquiculture was a rich subject for pictorial photographers such as Peter Henry Emerson, the noted English photographer whose aesthetic ideas were widely published in the United States. Curtis probably knew Emerson's writings as well as the famous 1886 image *Gathering Water Lilies.*

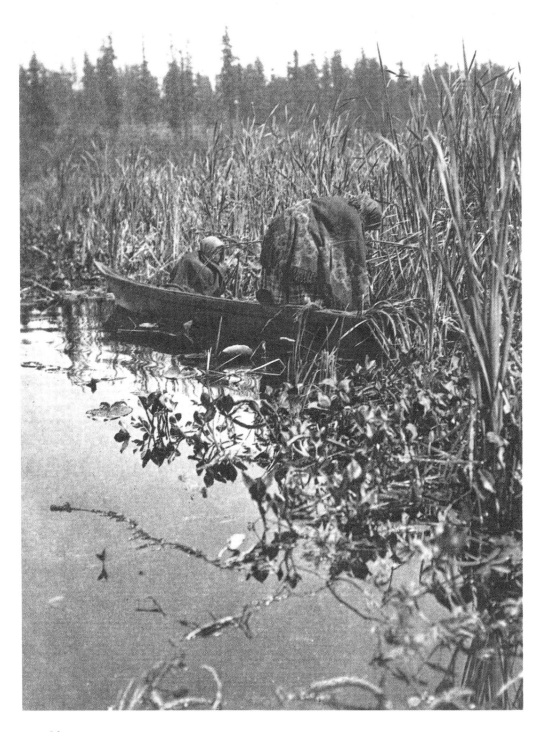

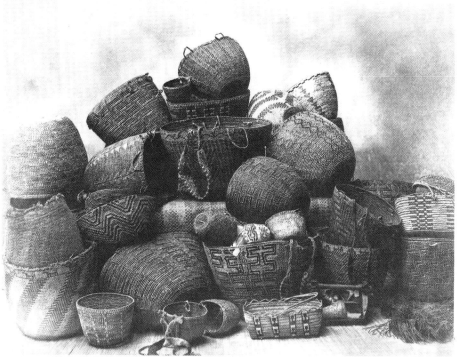

OPPOSITE:

Quilliute Girl, copyright 1912

Similar to Curtis's other stylishly draped portraits, this image dramatizes the exotic, recalling his early exhibition photographs. Despite his interest in ethnography, he never lost his commitment to pictorialism.

ABOVE:

Grave House – Snohomish, copyright 1912

Curtis frequently published images in *The North American Indian* which are not referenced in the text. In few instances did Curtis have images that specifically illustrated the text of the volumes.

ABOVE:

Puget Sound Baskets, copyright 1912

Native American crafts were as much of interest to Curtis as were the costumes of his subjects. In fact, the pleasing arrangement of baskets in this image suggests a kind of group portrait.

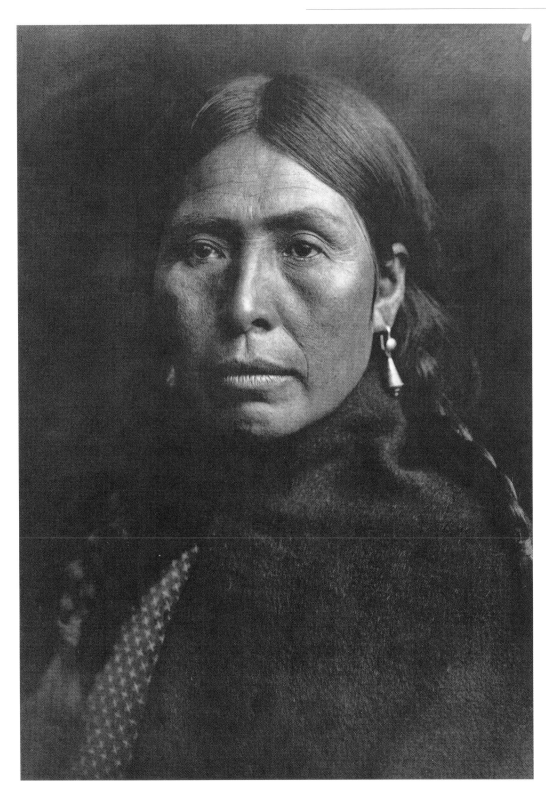

LEFT:

Lummi Type, copyright 1899

One of the most memorable of Curtis's portraits, this image demonstrates Curtis's ability to bring out strength of character. Even though the face is broad at the cheekbones, Curtis again daringly and successfully lit the face broadly.

OPPOSITE:

The Octopus Catcher, Qagyuhl, copyright 1914

Curtis so admired the Kwakiutl, one of the seafaring tribes of British Columbia and Alaska, that he devoted a whole volume to them, and expanded the book without making it thicker by having it printed on thinner paper. He said: "The people and the region...are unusual material for the ethnologist and the artist."

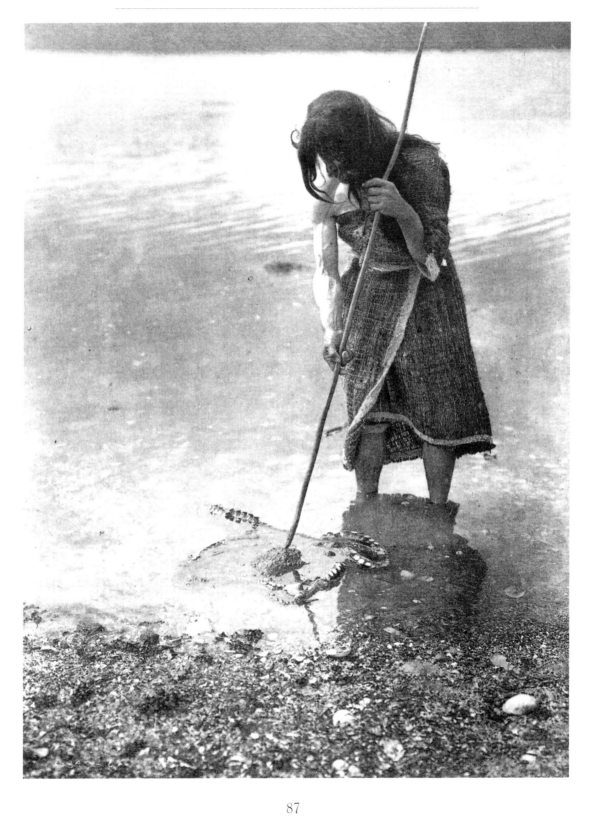

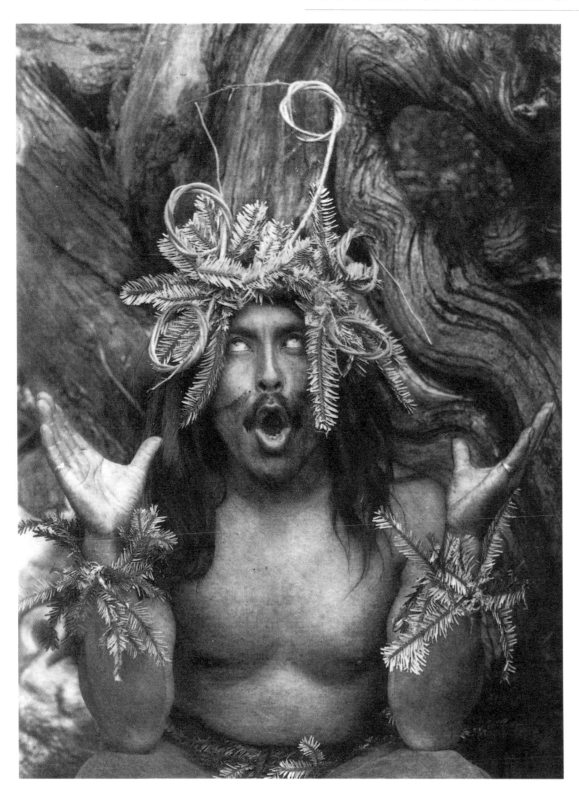

LEFT:

Hamatsa Emerging from the Woods, Koskimo,
copyright 1914

Curtis found that the winter dance rituals of the Kwakiutl were very unusual. A man seeking a higher level in the secret religious society controlling the dance ritual concealed himself in the woods in the company of a mythical ancestor. Hamatsa was the highest level, and supposedly required the aspirant to eat human flesh.

OPPOSITE:

Carved Posts at Alert Bay, copyright 1914

Curtis carefully positioned the two Nimkish heraldic columns so that they were equidistant from the edges of his image. He also aligned the eagle on the right-hand column within the frame of the house. Artistic considerations almost always guided Curtis's approach to photography.

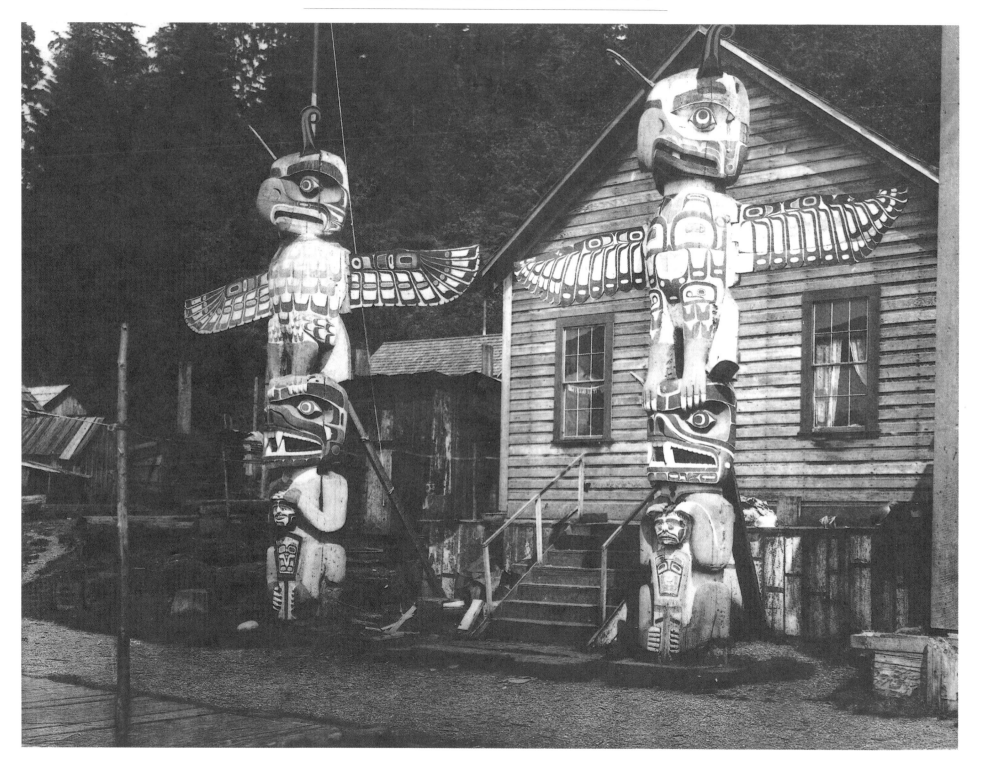

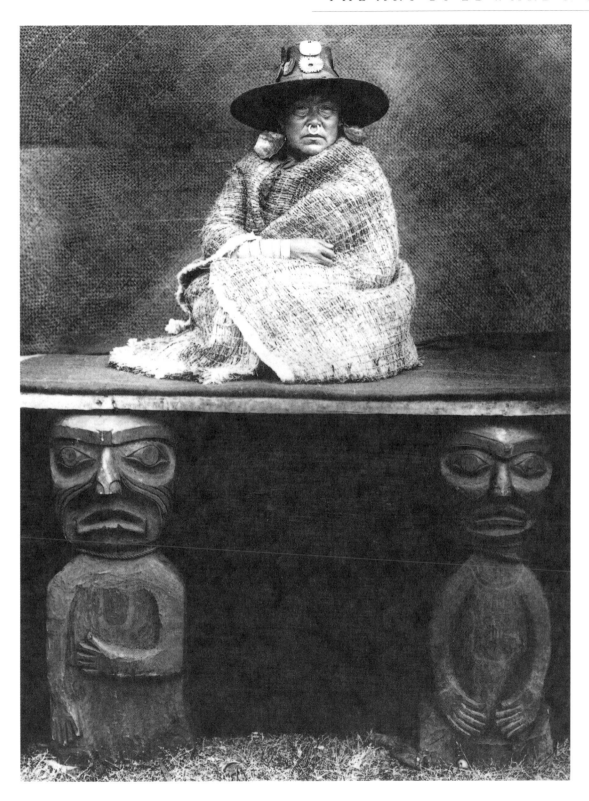

LEFT:

A Nakoaktok Chief's Daughter, copyright 1914

Once again symmetry dominated Curtis's concept for the photograph. Describing the image, Curtis observed: "When the head chief of the Nakoaktok holds a potlatch, his eldest daughter is thus enthroned, symbolically supported on the heads of her slaves."

OPPOSITE:

Kotsuis and Hohhuq, Nakoaktok, copyright 1914

Fascinated by the ritual of the winter dance, Curtis photographed these two performers masked as huge mythical birds, servants in the house of a cannibalistic monster. The mandibles of the masks are controlled by strings.

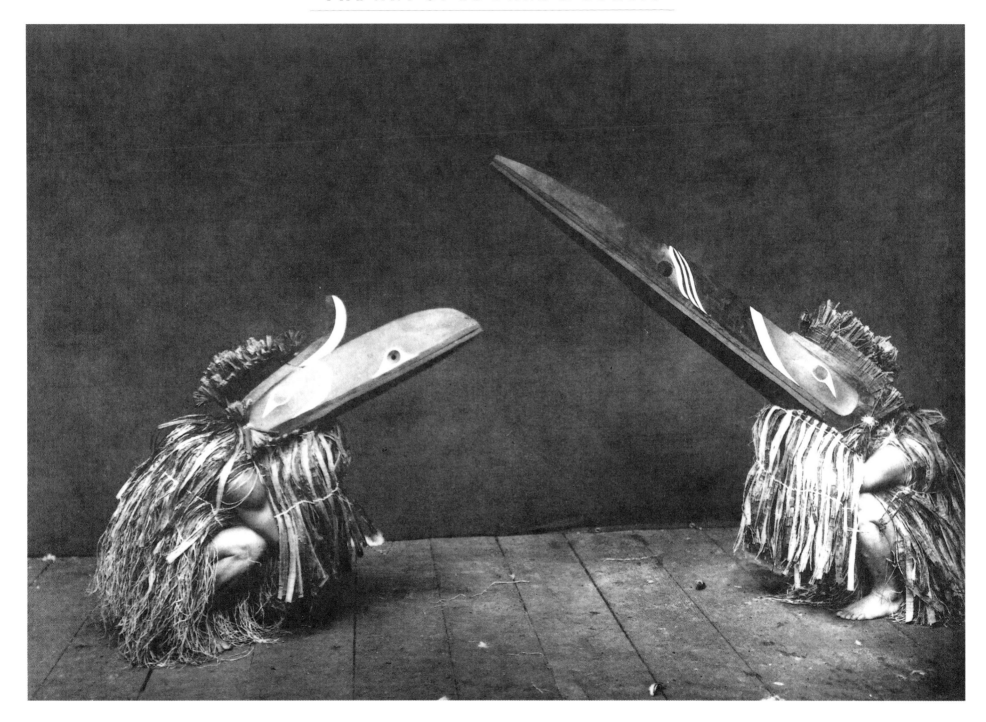

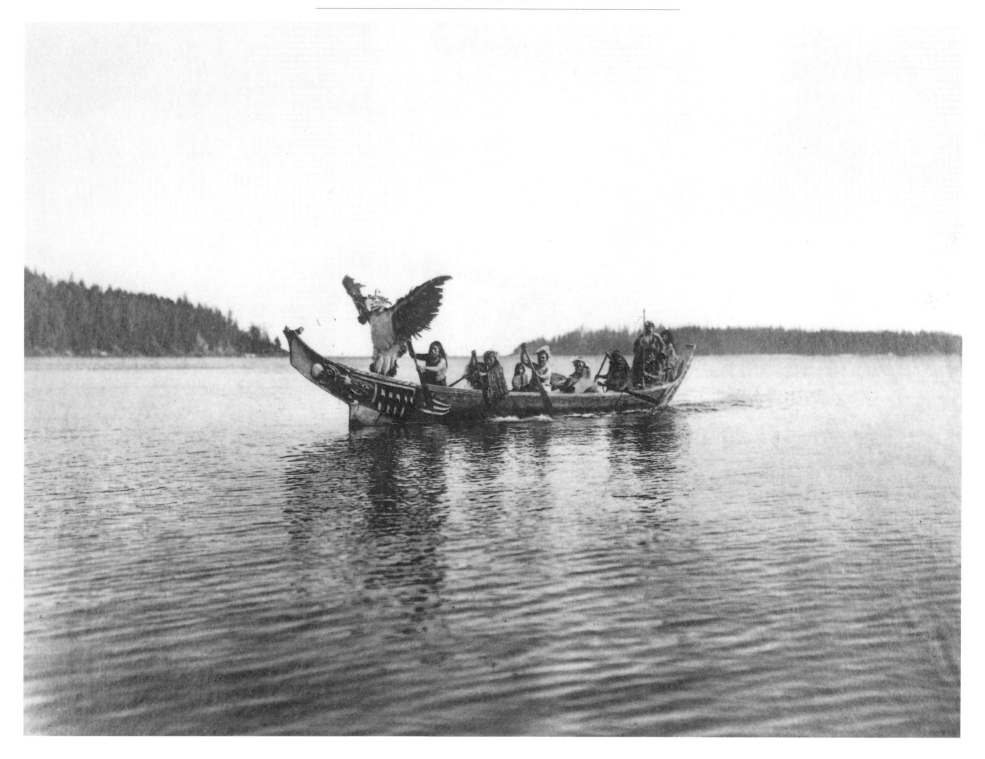

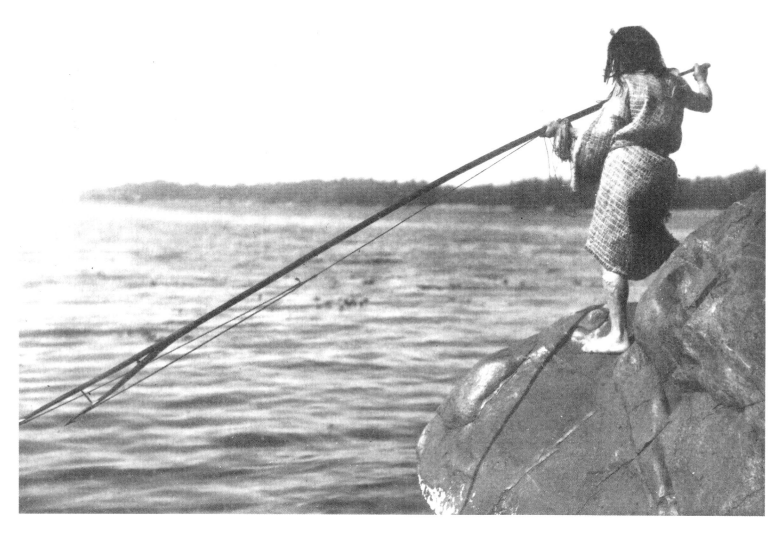

OPPOSITE:

Coming for the Bride, Qagyuhl, copyright 1914

In the Kwakiutl wedding ceremony, the groom typically arrived at the bride's village in a canoe with a dancer dressed as a thunderbird making characteristic gestures in the prow. Curtis choreographed the scene as a movie director would, waiting for the perfect arrangement of the dancer framed by the landscape.

ABOVE:

Ready to Throw the Harpoon, copyright 1915

Traditional costumes had to be woven before Curtis could make this photograph of a Nootka man fishing. Impressed with the ingenuity of the Nootka, Curtis made images that were as attractive as they were narrative.

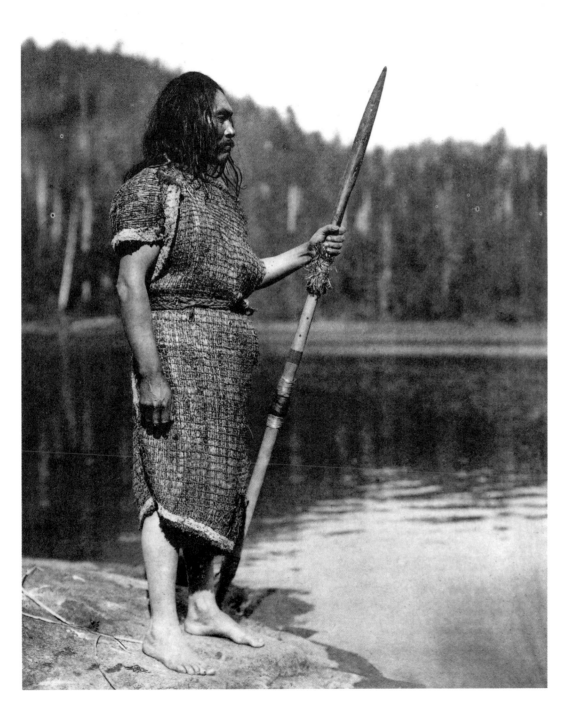

LEFT:
The Whaler, Clayoquot, copyright 1915

Usually Curtis preferred simple and direct pictorial arrangements. A single figure, his head aligned with the horizon and his spear strategically placed at the intersecting lines of the landscape, was positioned facing the broader portion of the image. The spear, incidentally, is that of a warrior, not a whaler.

OPPOSITE:
On the Shores at Nootka, copyright 1915

Of this image, Curtis said: "Two women...rest on the beach while waiting for the tide to fall and uncover the clam-beds." His description makes the arrangement sound casual, but he has, in fact, made a formally composed picture.

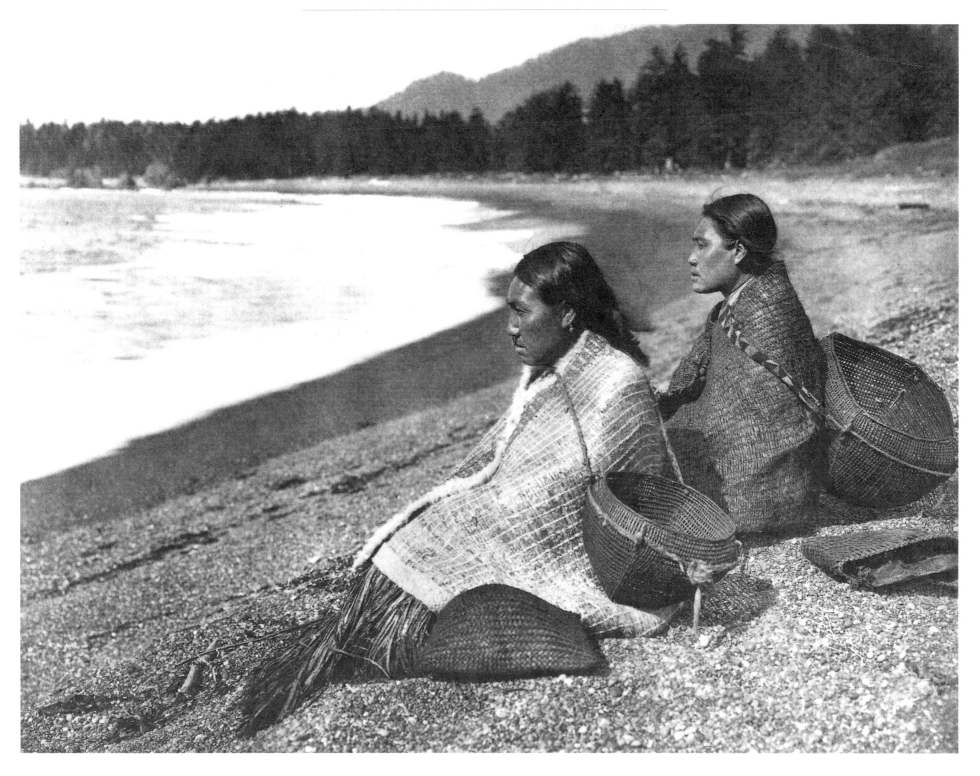

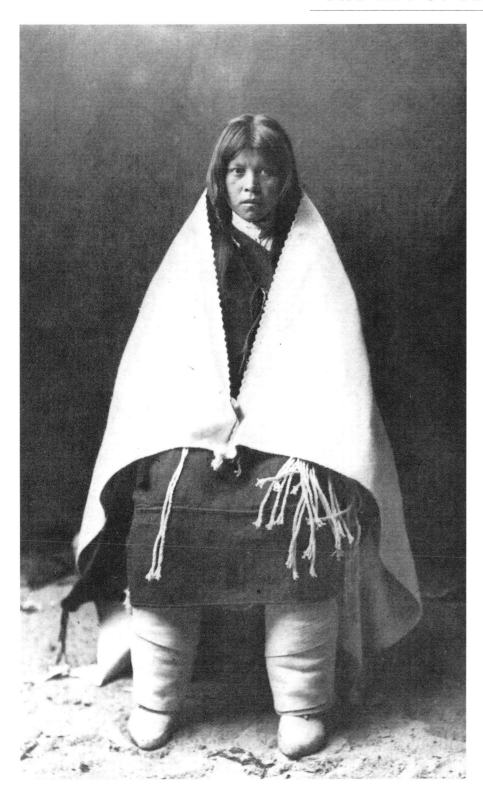

LEFT:
Hopi Bridal Costume, copyright 1900

Curtis evidently photographed this young woman in bridal costume to show its elaborateness, perhaps a symbol for the complex and layered Hopi courtship and marriage ritual.

OPPOSITE:
Hopi Farmers, Yesterday and Today, copyright 1906

Curtis rarely compromised his intention to show only the old ways, but the contrast between the past and present occasionally made especially interesting pictorial imagery.

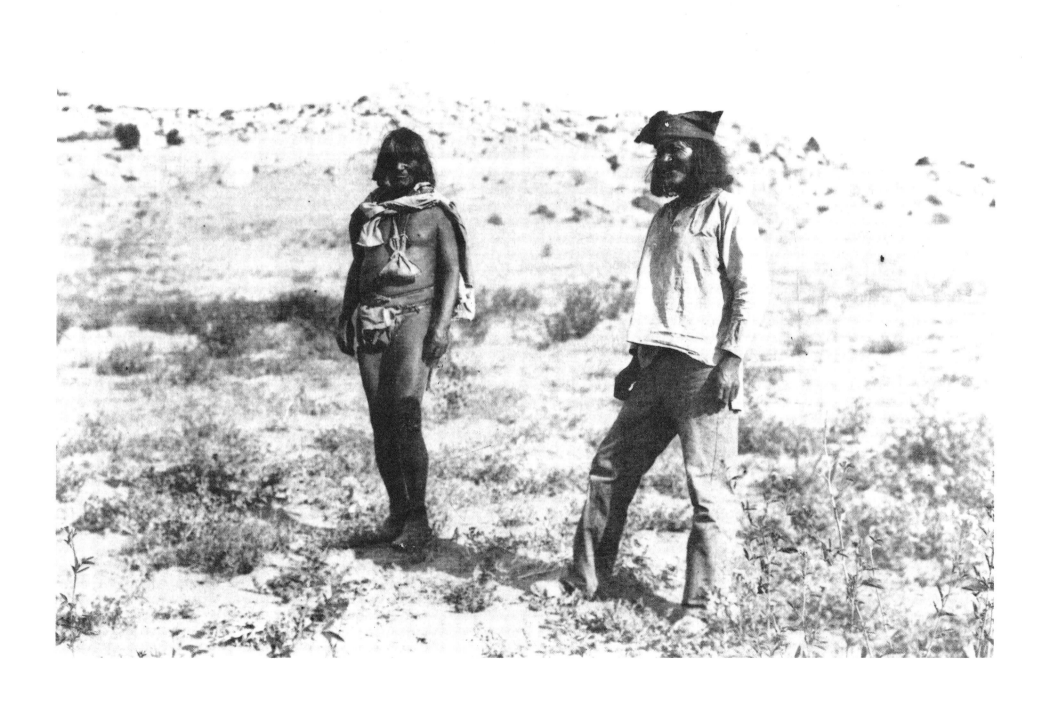

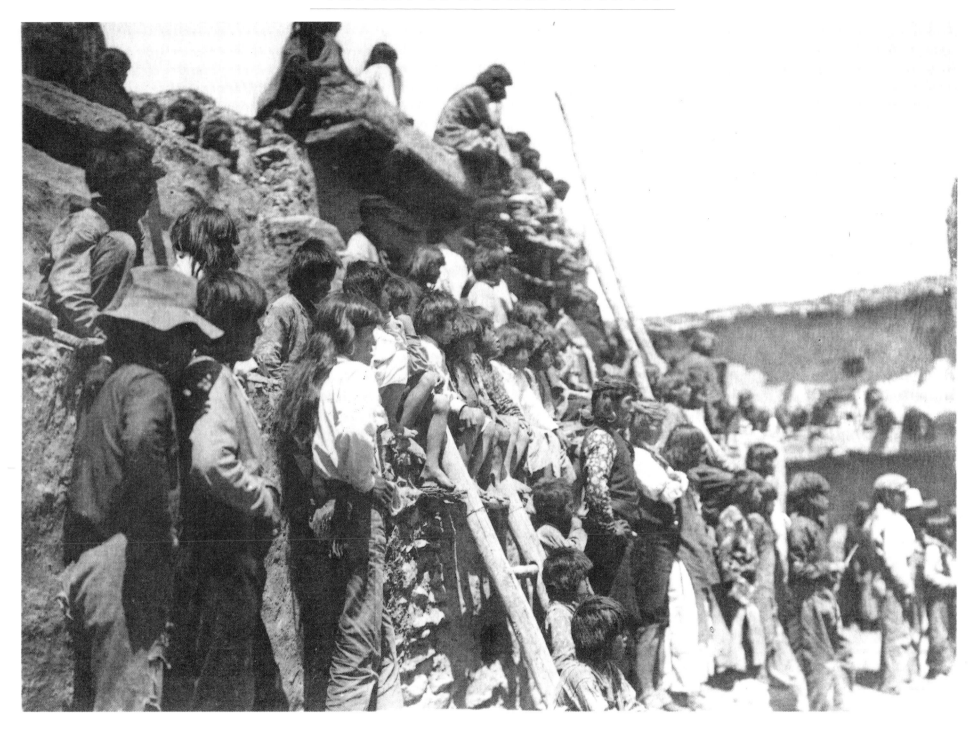

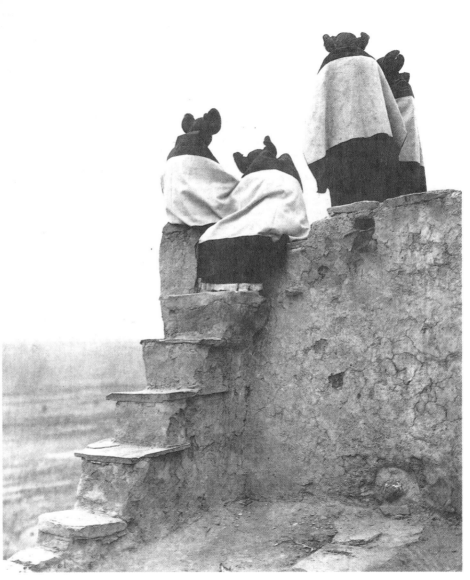

OPPOSITE:

Spectators at the Snake Dance, copyright 1905

The Snake Dance, a 16-day rite and prayer for rain, involved ceremoniously collecting snakes and, after a number of rituals, featuring them as part of the dance. Curtis photographed Native Americans in contemporary clothing as they watched the spectacle. Among the 2,228 images in *The North American Indian*, only a handful show Indians in contemporary clothing.

ABOVE:

Potter Building Her Kiln, copyright 1906

Like the pictorial images Curtis made of the clam diggers, in this photograph little insight is provided about how the individual built her kiln. The image is more a study of visual balances between the figure and the rock on the right and the texture and atmospheric perspective on the left.

RIGHT:

Watching the Dancers, copyright 1906

The graphic shapes attracted Curtis to make this image showing girls on the topmost roof of the Hopi city of Walpi looking down into the plaza and watching the Snake Dance.

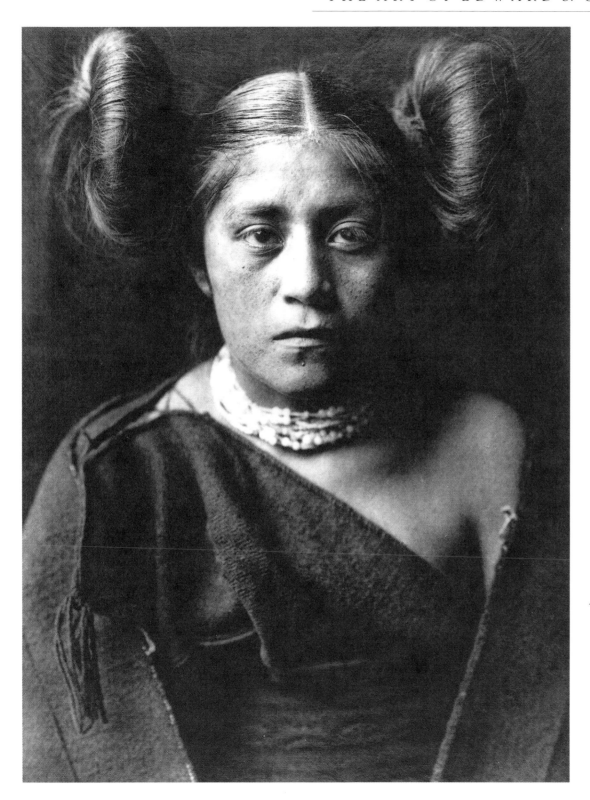

LEFT:
A Tewa Girl, copyright 1921

This intense image relies upon symmetry and lighting carefully arranged to illuminate the striking hairstyle of the young woman. The hairstyle is traditional, and indicates that she is unmarried.

OPPOSITE:
Snake Dancers Entering the Plaza, copyright 1921

Curtis was fascinated by the Snake Dance, and photographed the entire event. In 1912, he participated fully in the ritual as an inductee into the Hopi Snake fraternity, a status no outsider had attained up to that time. The event made headlines in newspapers across the country.

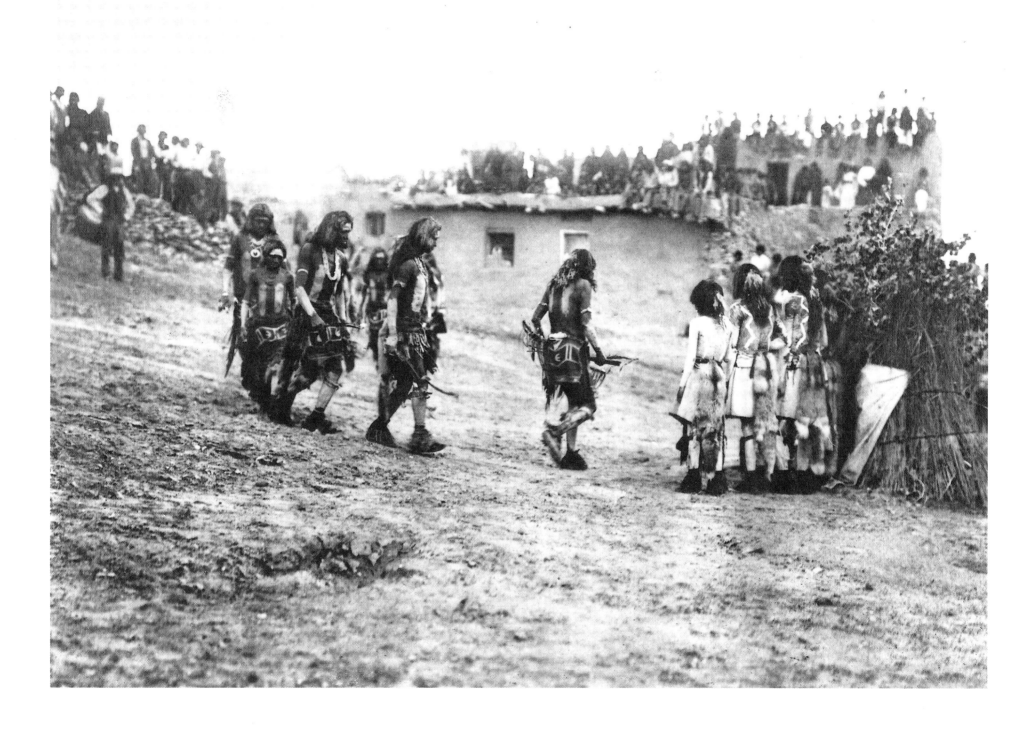

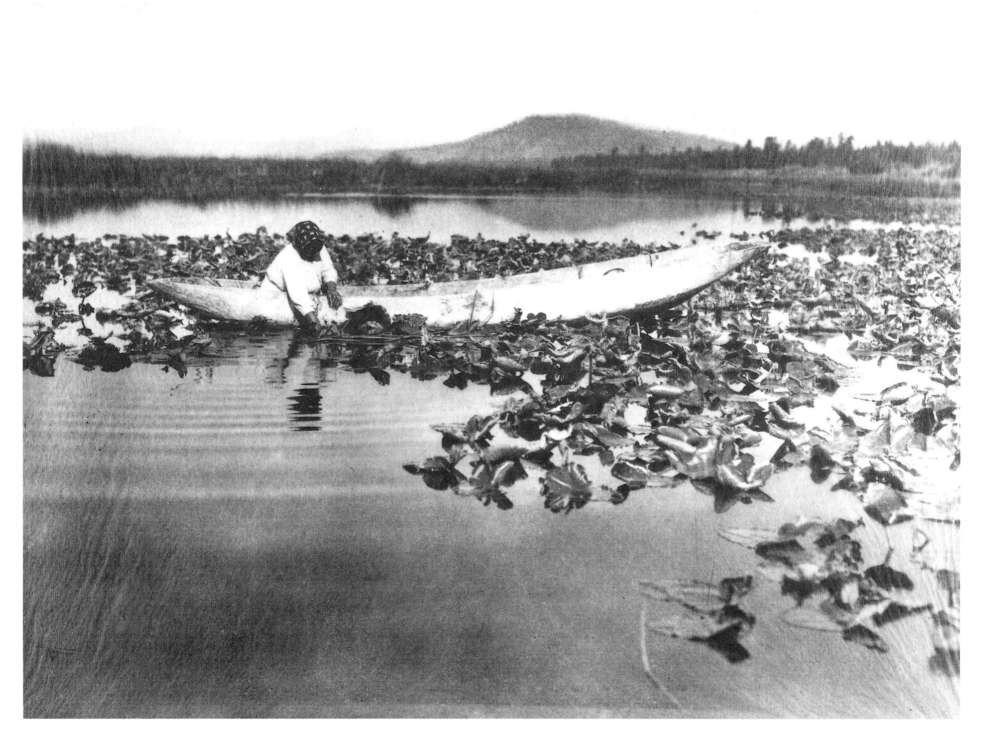

OPPOSITE:
Gathering Wokas, Klamath, copyright 1923

The seeds of water lilies (wokas) were once a staple food of the Klamath, but later became a luxury, Curtis observed. They were harvested from the extensive marshes surrounding Klamath Lake in Oregon.

RIGHT:
A Mixed-Blood Coast Pomo, copyright 1924

The gentle features of this man are accentuated by soft light and focus. Curtis's admiration for the subject shows in the noble rendering he produced. The Pomo were located in northern California near Mendocino. Curtis observed that at one time there were nearly 100 different languages spoken in what is now California.

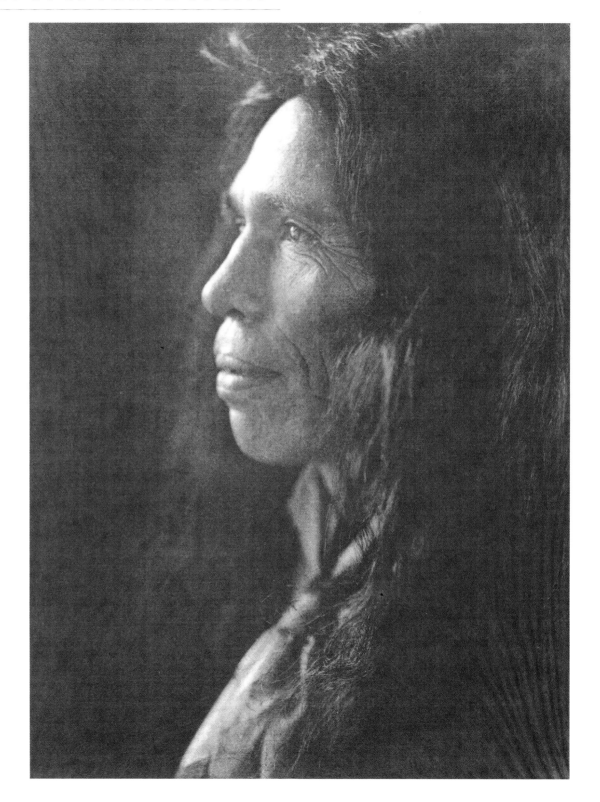

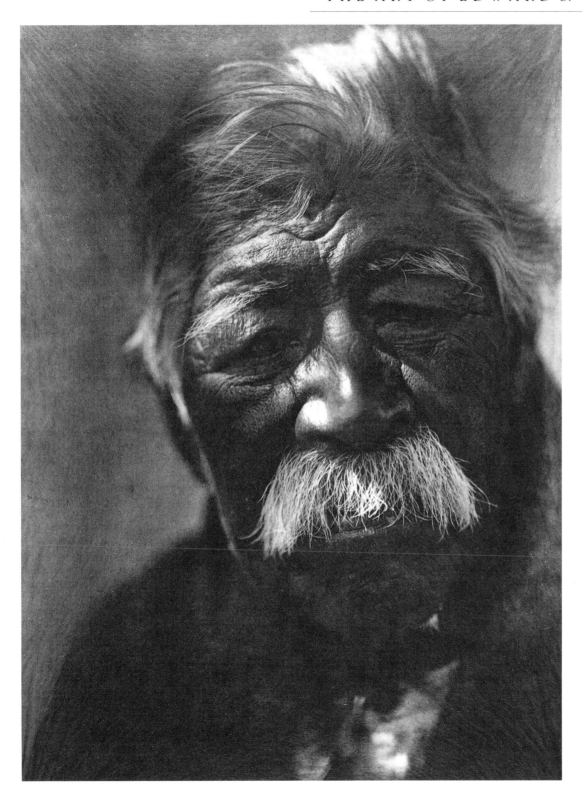

Shatila, Pomo, copyright 1924

Curtis understood that portraits were performances between photographer and subject. The photographer, wanting to achieve a certain look, spoke or made gestures to get that image. The subject, in turn, wanting to appear a certain way in the image, reacted or responded to the photographer.

OPPOSITE:

Canoe of Tules, Pomo, copyright 1924

In this image, Curtis sought to equate visually the bundles of reeds used to make the canoe with those growing at the water's edge. The man is diminished in importance, but is still the center of attention, while the gradations of light gray in the murky water serve the same function as the plain backdrops in most of his portraits.

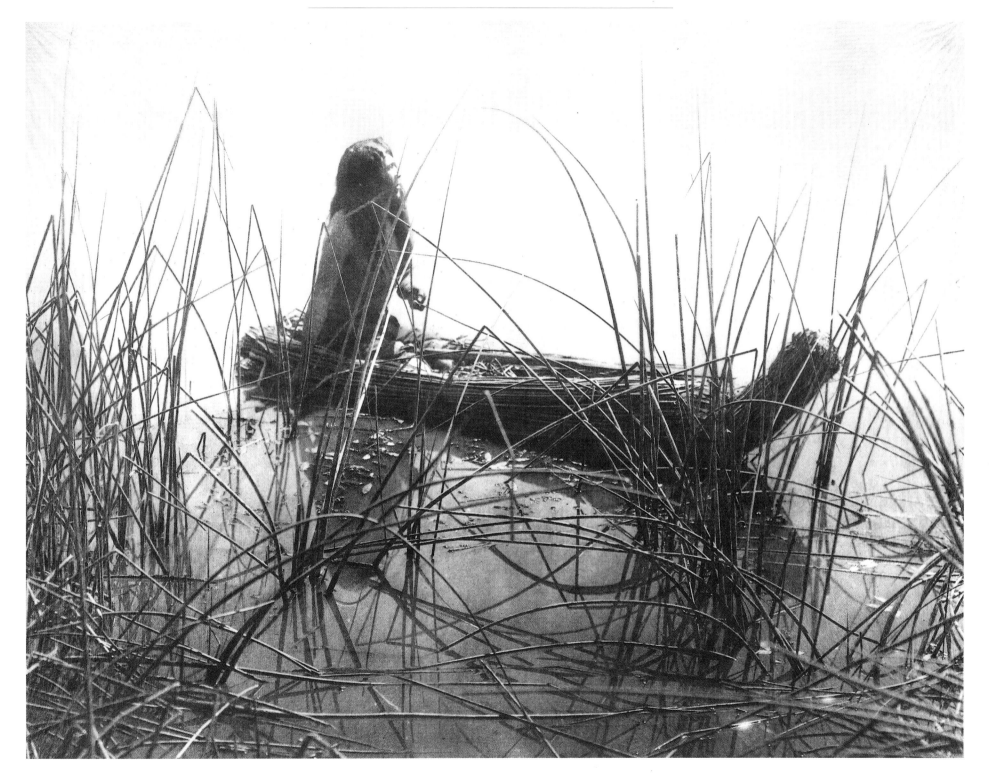

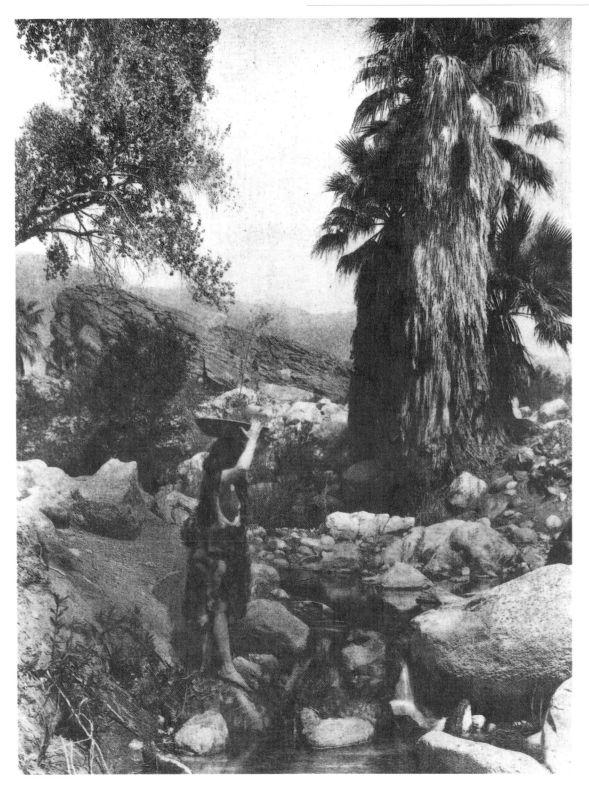

LEFT:

Andres Canyon, Cahuilla, copyright 1924

The Garden of Eden is evoked in this idyllic southern California scene. The young Cahuilla woman might be viewed as Curtis's Eve, who is carrying fruits of knowledge.

OPPOSITE:

Washo Baskets, copyright 1924

Baskets used for carrying food, parching seeds and storage are the basis for this still life arrangement. Curtis angled the round basket openings so that they appeared oval in shape, directing the eye of the viewer to the next part of the image.

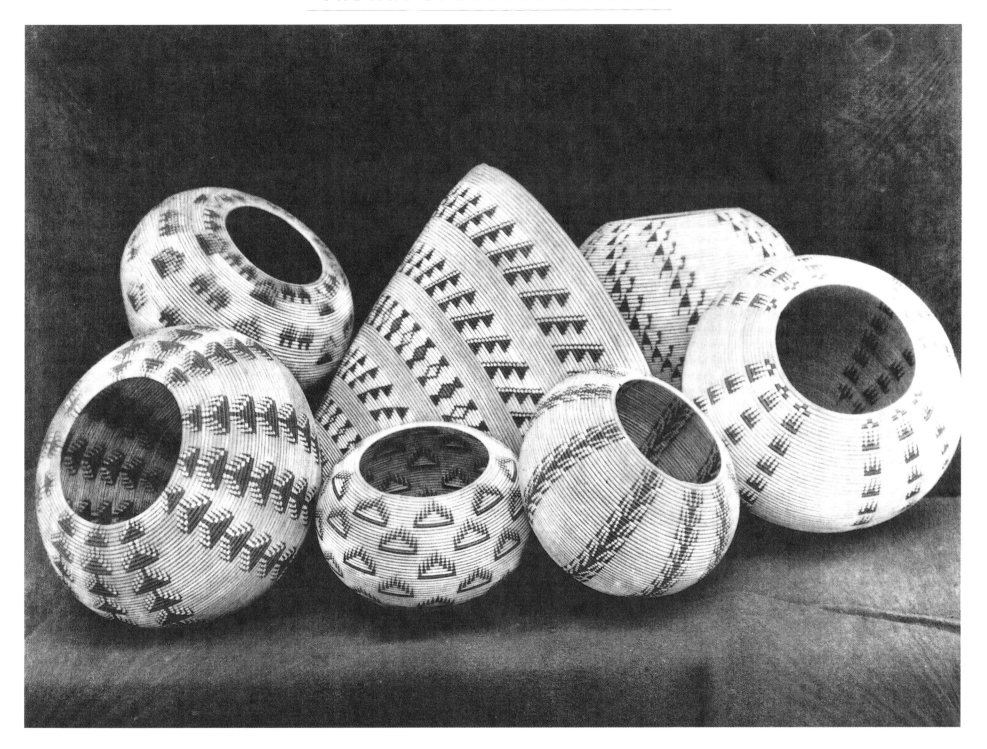

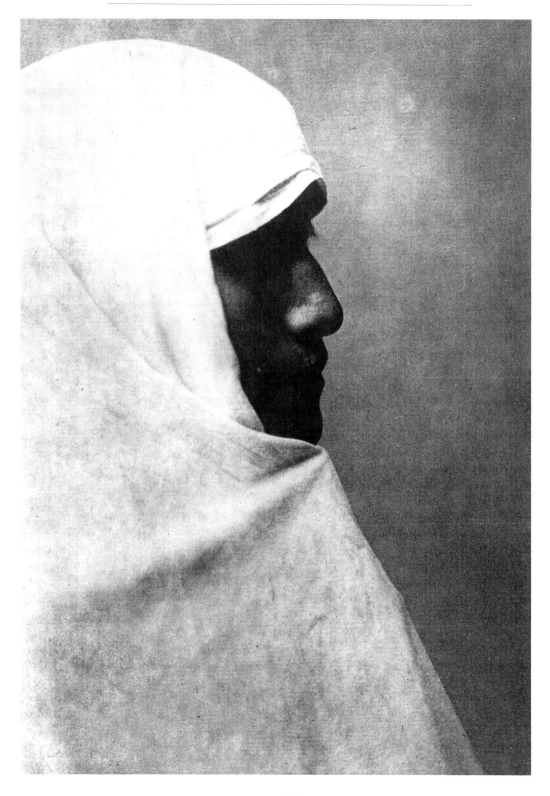

OPPOSITE:
Pavia, Taos, copyright 1905

The figure in this image looks mysterious and exotic, qualities that strongly appealed to Curtis and had been features of his photographs since the 1890s. The painterly quality is designed to achieve the most careful and harmonious balances among the various parts of the image.

RIGHT:
A Taos Girl, copyright 1905

With the same facility with which he made one sitter look powerful and exotic, Curtis made another look petite and vulnerable. He wielded his camera artfully to achieve the look he sought in a particular image.

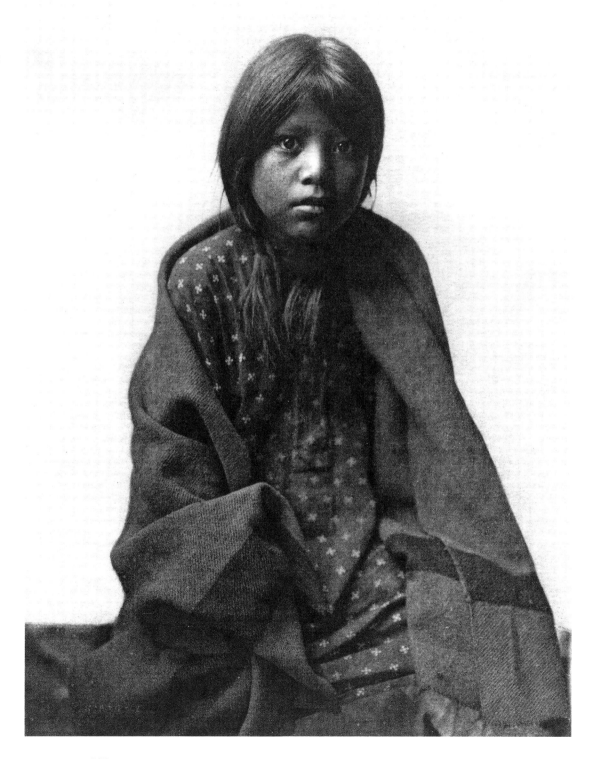

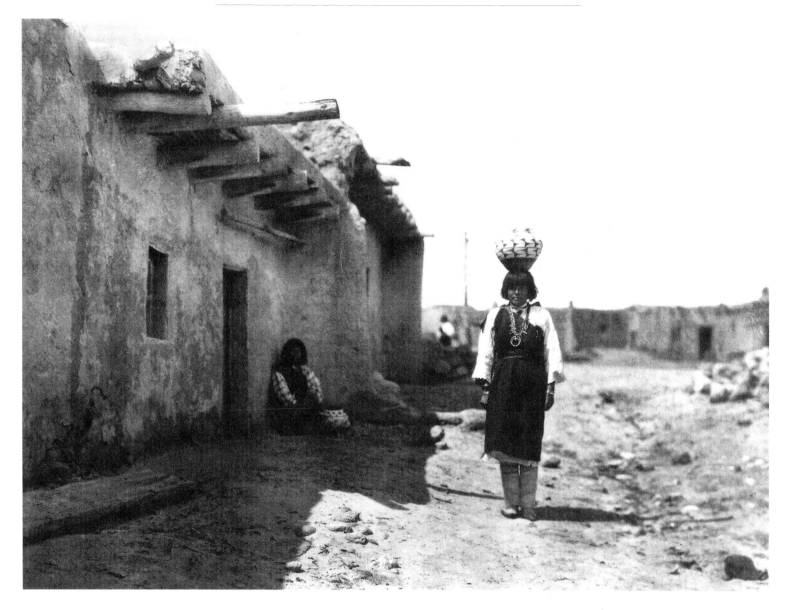

ABOVE:

Sia Street Scene, copyright 1925

It is difficult to judge what is truth or invention in Curtis's photographs; consequently, one does not know whether a particular image can be relied upon for its ethnographic information. Artfulness, on the other hand, is almost always believable in Curtis's work, and this image is a good example.

OPPOSITE:

A Feast Day at Acoma, copyright 1904

Franciscan missionaries in the seventeenth century declared St. Stephen, the first Christian martyr, to be the patron saint of Acoma, New Mexico. On a Feast Day of St. Stephen, Curtis made this dramatic image of Acoma, and burned in the sky such that it appeared the people were actually waiting for St. Stephen himself to appear.

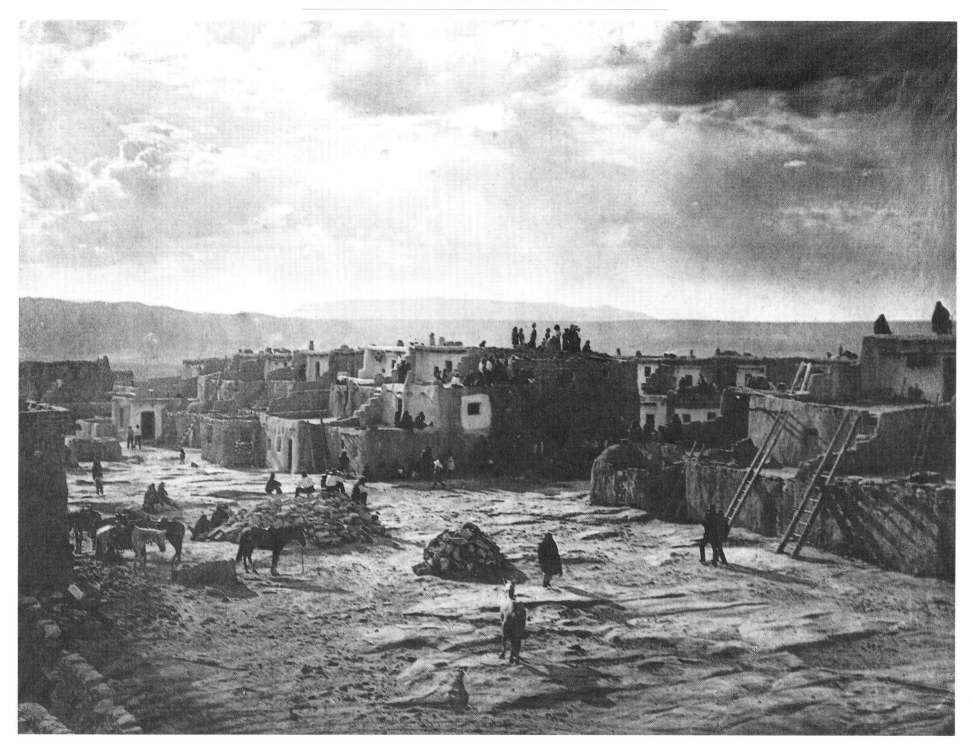

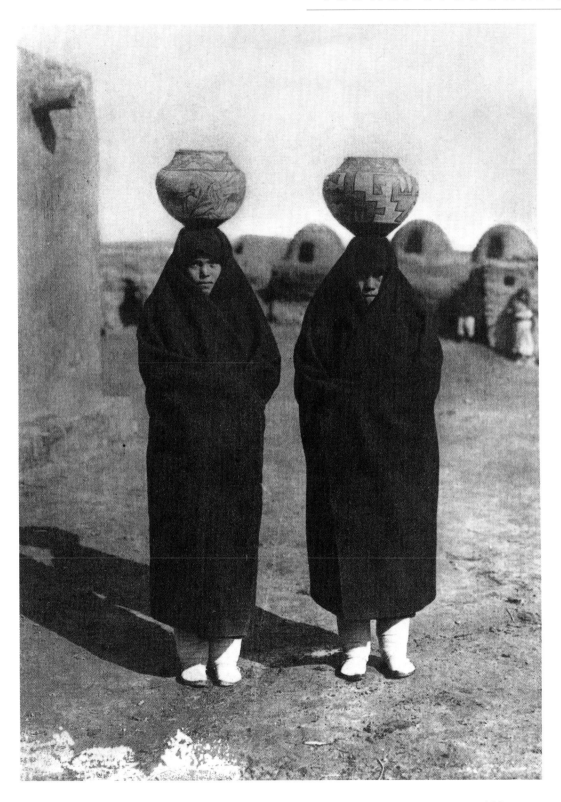

LEFT:

Zuni Water Carriers, copyright 1903

The rhythm of curvilinear shapes in this image must have strongly appealed to Curtis, and became the basis of the design. Evidently the image was so popular that Curtis published it as a postcard in 1904.

OPPOSITE:

Shiwawatiwa, Zuni, copyright 1903

Unafraid to confront his sitters, Curtis often moved the camera close and filled the image with the detailed features of a sitter's face. This man seemed to be jauntily sizing up Curtis, and consequently viewers of the image, but was not quite willing to smile about what he saw.

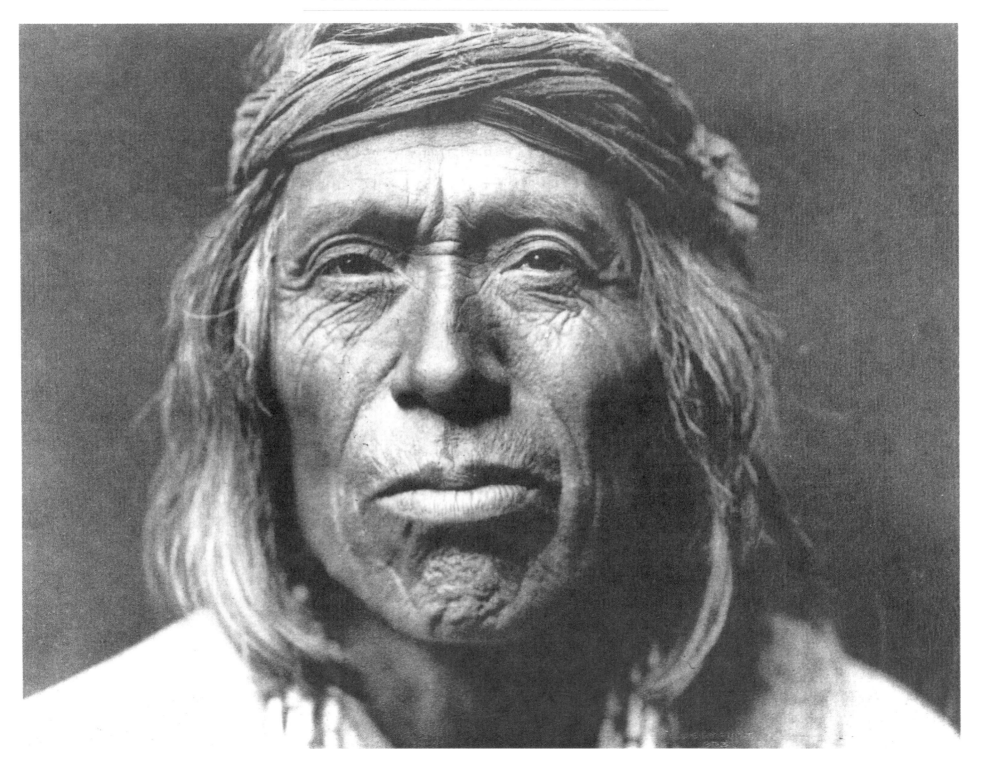

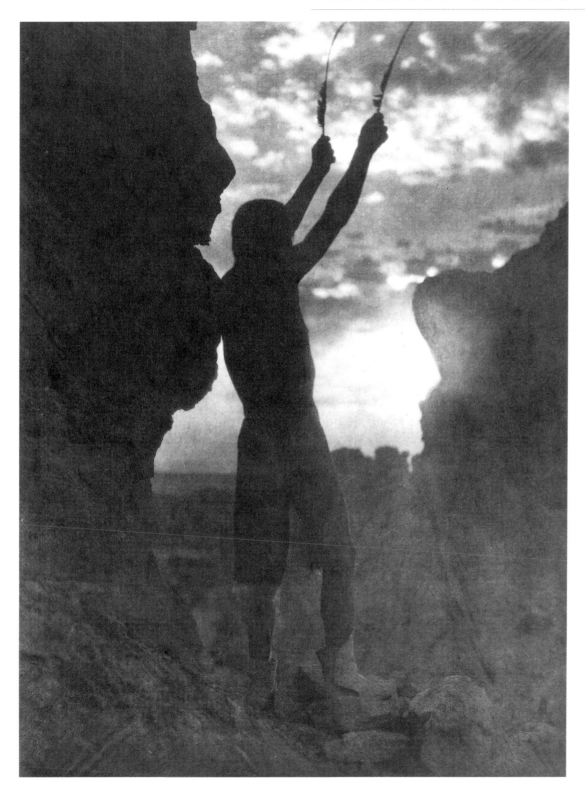

LEFT:

Offering to the Sun, San Ildefonso, copyright 1925

An offering to the sun was almost a daily part of Tewa life, a rite which Curtis saw in graphic terms. By employing back lighting, both the man making the offering and sun could be incorporated into the image.

OPPOSITE:

On the Rio Grande, San Ildefonso, copyright 1905

Only the subjects are sharply focused in this very painterly image. Curtis, like other pictorialists, preferred impressionistic results and used a wide aperture, therefore diminishing depth of focus to achieve that effect.

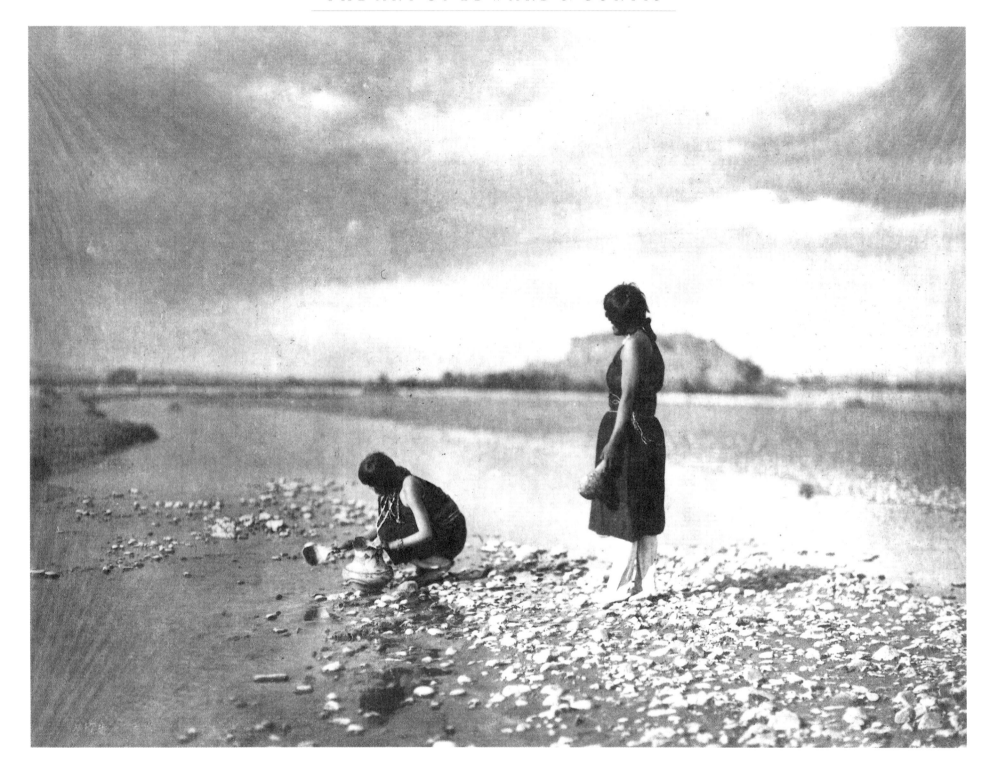

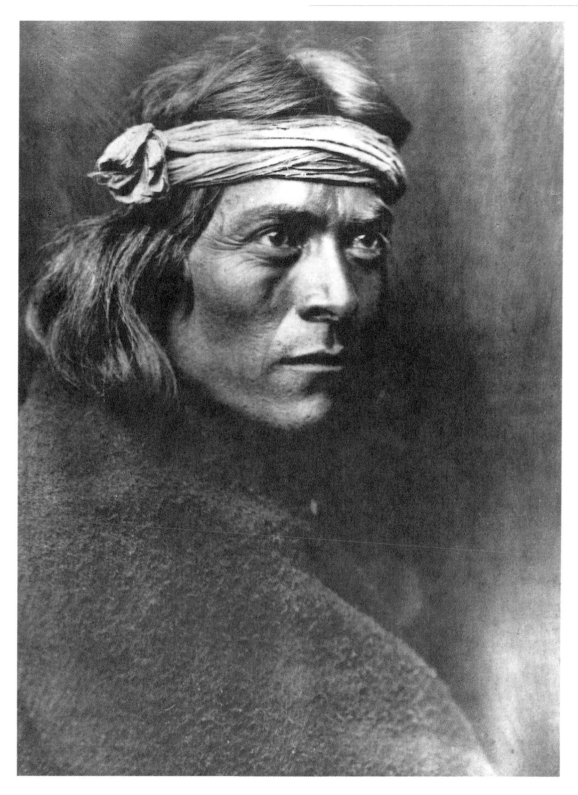

LEFT:

A Zuni Governor, copyright 1925

Wanting to emphasize the physiognomy of the sitter, Curtis lit the subject from above, so that highlights would fall on the forehead, cheekbones, nose and mouth. The result is an intense and dramatic portrait.

OPPOSITE:

An Offering at the Waterfall, Nambe, copyright 1925

Curtis said of this image: "Feather offerings are deposited in numerous shrines, buried in the earth near the pueblo, and placed in springs, streams, and lakes, for the purpose of winning the favor of the cloud-gods."

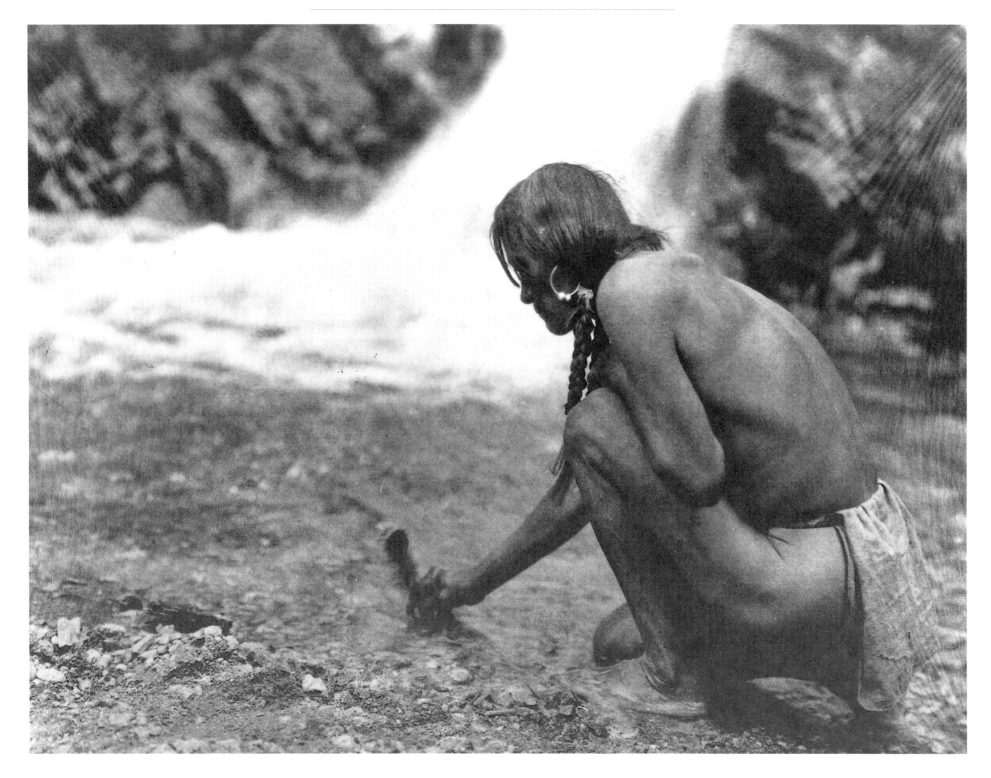

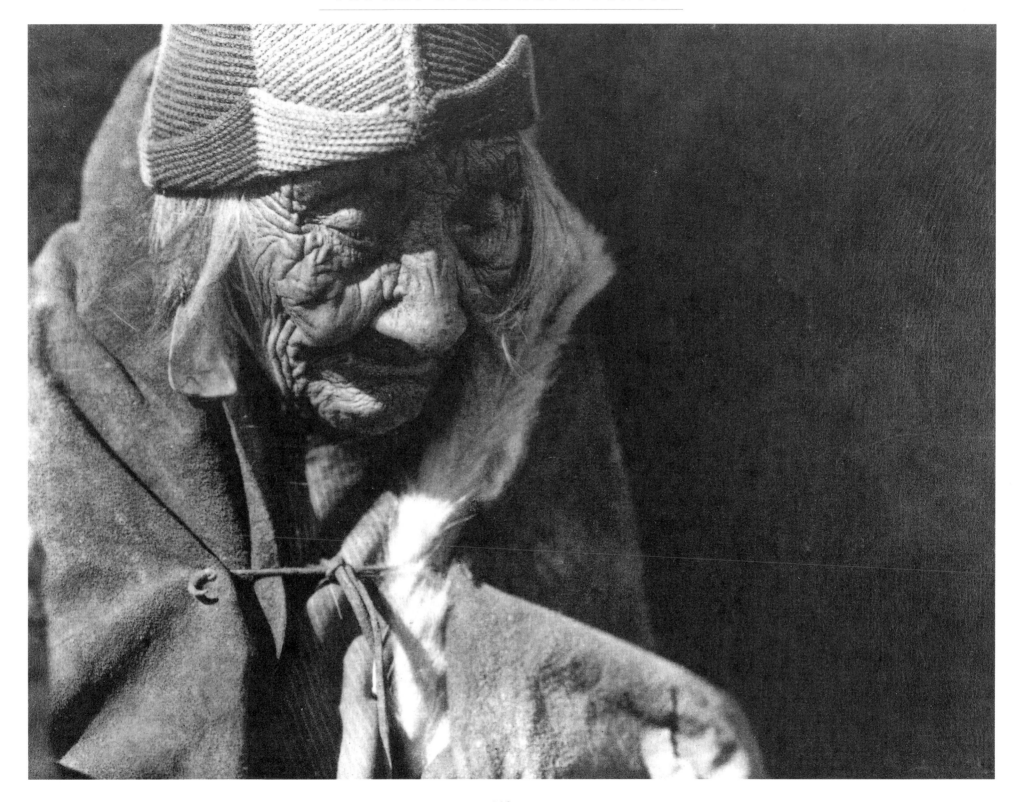

OPPOSITE:
An Old Woman, Blood, copyright 1926

In general, subjects Curtis photographed in the full light of the sun were slightly turned away from the direct light. The effect in this image of an elderly woman is that the raking light accentuates the wrinkles in her face.

RIGHT:
A Cree Camp at Lac Les Isles, copyright 1926

The camp of the Cree in this image seems to have been of less interest to Curtis than the pictorial relationship between the trees and the lodge.

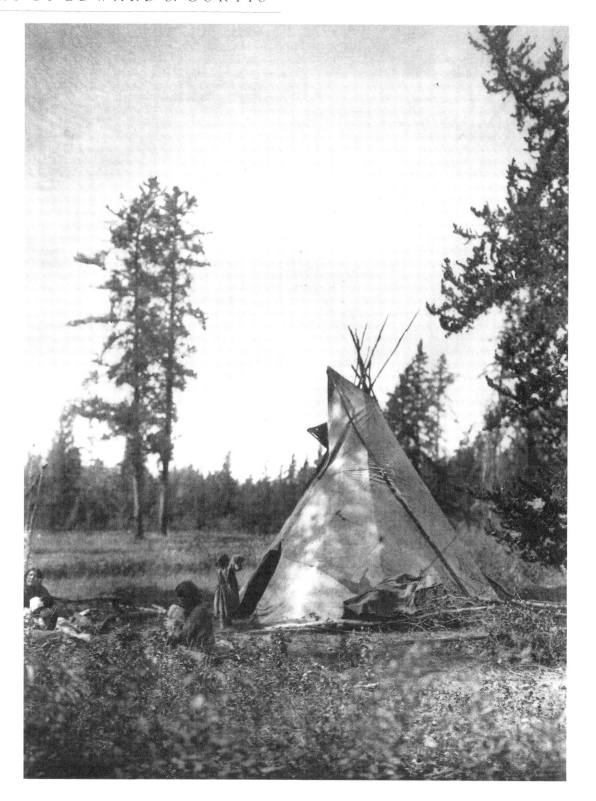

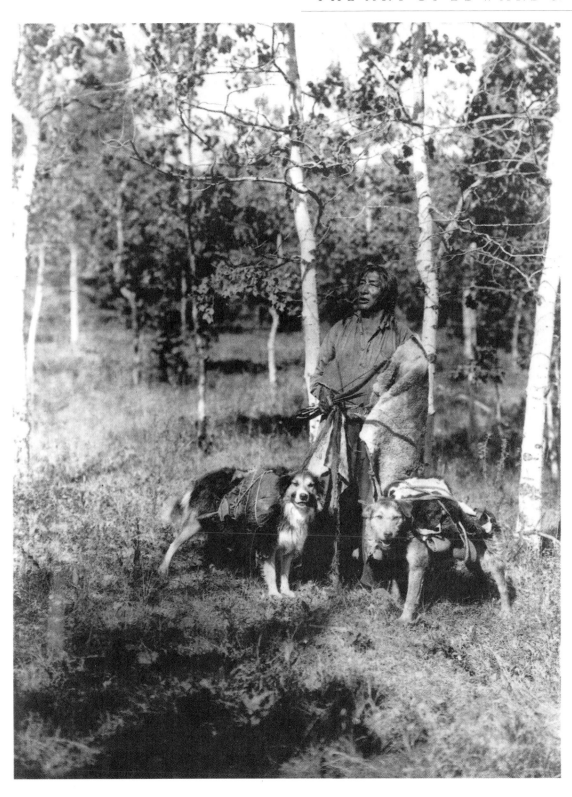

LEFT:

Assiniboin Hunter, copyright 1926

Style is always at the service of Curtis's romantic vision. Even in this image where the dogs look toward the camera, nothing is by chance. Every element of the picture is carefully planned to fit together neatly, pictorially.

OPPOSITE:

A Painted Tipi, Assiniboin, copyright 1926

The lodge in this image was painted by its owner to commemorate a dream. A dream-like quality pervades Curtis's image, since the perspective is somewhat distorted. The boy and horse seem unusually large, and the boy's mother is strangely small.

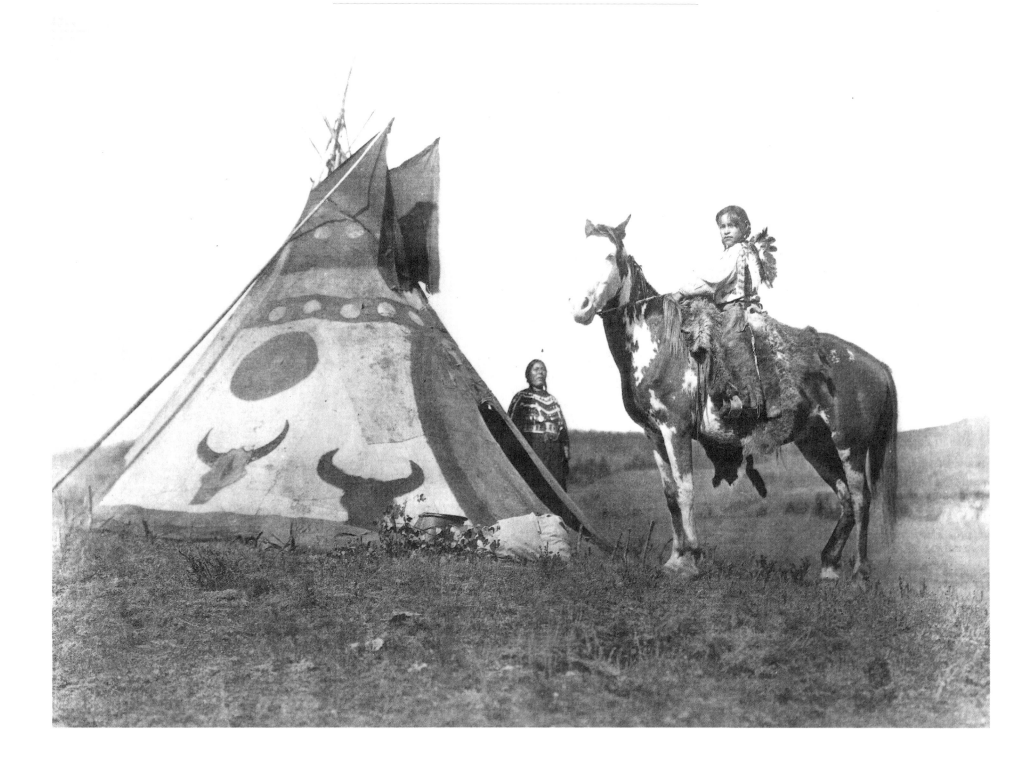

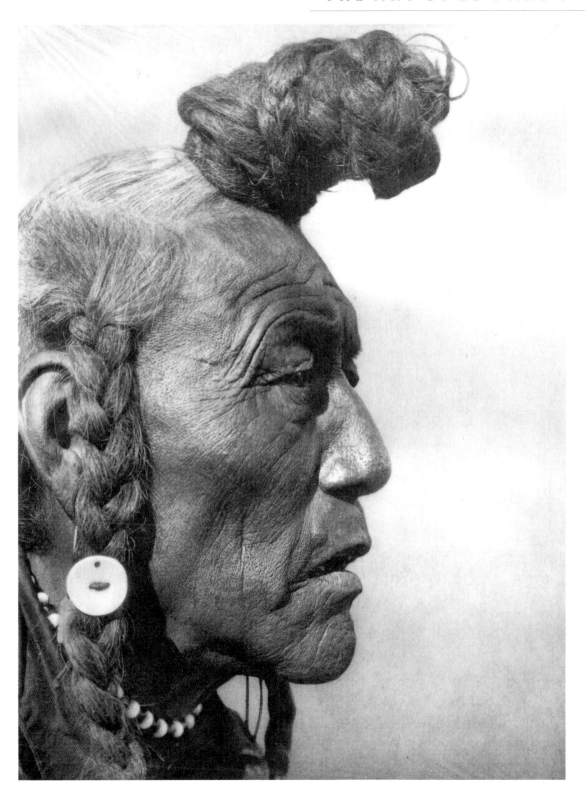

LEFT:

Bear Bull – Blackfoot, copyright 1926

Generally, Curtis's approach to his images is easily decipherable, such as in this one where the hairstyle is obviously the reason for the image. Illustrated is "an ancient method of arranging the hair," Curtis said.

OPPOSITE:

Placating the Spirit of a Slain Eagle – Assiniboin, copyright 1926

Elaborate ceremonies characterized capturing, killing and utilizing the skins and feathers of eagles, which were considered sacred birds to many Native Americans. Curtis sought to convey in this image something of the ritual related to eagles through the display of the dead bird with the ceremonial rattle.

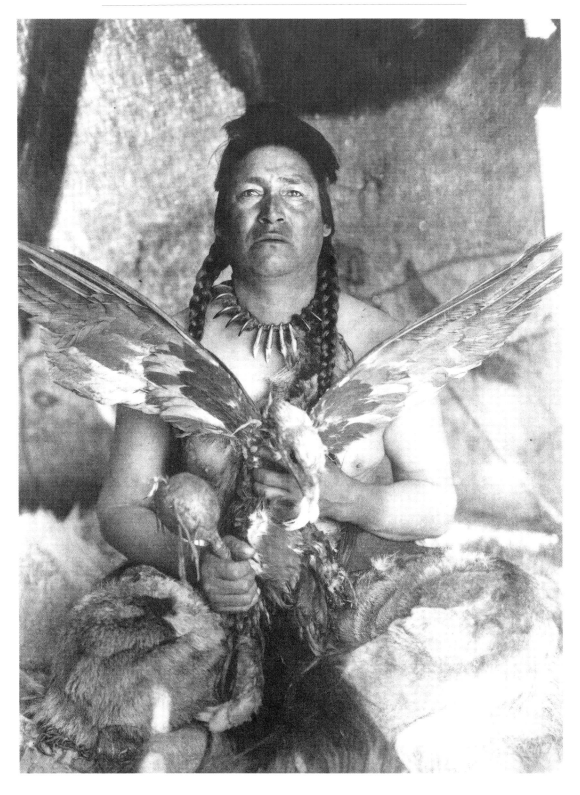

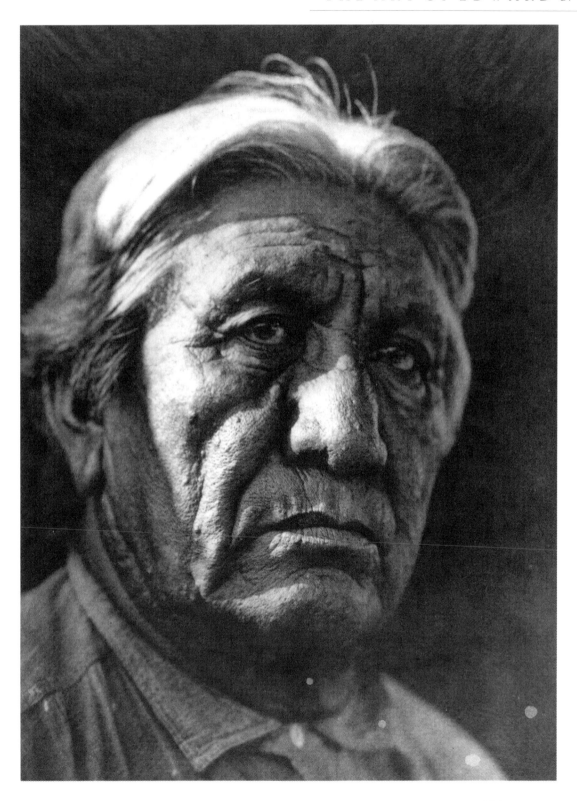

LEFT:

Reuben Taylor (Istofhuts), Cheyenne, copyright 1927

Toward the end of his massive project, Curtis made even greater concessions to the contemporary look of Native Americans. In this image, the man wears a denim shirt and has short hair. Nonetheless, the image is still powerful; Curtis had lost none of his ability as a portrait photographer.

OPPOSITE:

King Island Village from the Sea, copyright 1928

A pictorialist to the end, Curtis said of this image: "The King Islanders occupy dwellings erected on stilts on the cliff side, giving their village an unusual and highly picturesque appearance."

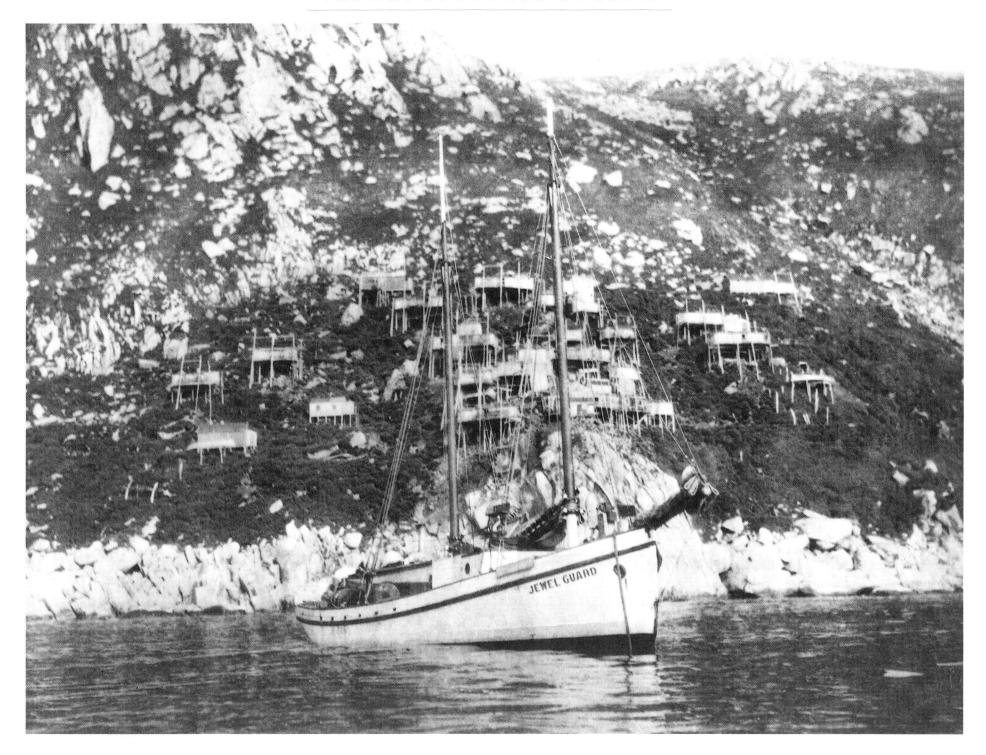

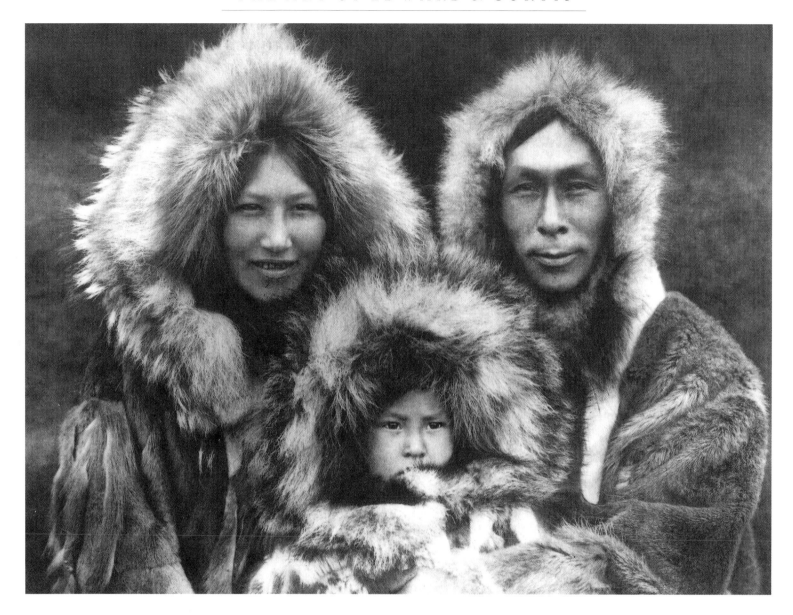

ABOVE:

A Family Group – Noatak, copyright 1928

This family portrait is as fine as any Curtis made in his Seattle studio. Having given up his family life for *The North American Indian*, he might well have been touched by the gentle and loving appearance of this family.

Notes

6	"Born. . . family future": Lawlor 10.
6	"In 1873. . . Little Crow's War": Lawlor 11-12, 15.
6-7	"Little Crow. . . paid first": Brown 39-40.
7	"Some young Santee men. . . settler's anger": Brown 43.
7	"The Santees attacked. . . that summer": Brown 62-63.
7	". . . until his grandfather's death. . . spiritual comfort": Lawlor 15-16.
7-8	"Whether the photographer. . . an artist": Wilson 17.
8	"Poor economic conditions. . . had built": Lawlor 18-19.
8	"Edward Curtis farmed. . . Puget Sound": Lawlor 21-22.
8	"Photographers adopted themes. . . rural life": Rosenblum 299.
9, 11	"He changed. . . and Photoengraver": Lawlor 22-23.
11	". . . Princess Angeline. . . of Seattle": Hodge 493.
12-13	"Curtis heard. . . with the Blackfeet": Davis 28.
13	"Looking down. . . their lives": Andrews 114.
13	"Fear that. . . no more": Fleming 11.
13, 15	"Catlin's first trip. . . acquired it": Fleming 18.
15-16	"In 1903. . . in their conquest": Davis 38-39.
17	"Newspaper headlines. . . Curtis's work": Davis 46.
17	"Articles chronicling. . . Curtis's fame": Graybill 78.
17	"While Clara. . . photography": Lawlor 22.
17	"To make matters. . . Connecticut": Davis 58.
18	"Clara filed. . . in 1918": *Seattle Daily Times* 19 June 1918.
18	"The Divorce. . . Native Americans": Graybill 88. Many original negatives were in New York and later were stored in the basement of the Morgan Library. During World War II, some were destroyed and others were sold as junk: Davis 78.
18	"Clara alleged. . . life's work": *Seattle Post Intelligencer* 12 October 1927.
18	"The Destination. . . as the mast": Graybill 98-99.
18	"The storm. . . greet us": Graybill 97-105.
18	"His daughter Beth. . . possible": Lawlor 108.
20	"Curtis spent. . . to safety": Davis 78-79.
20-21	"In the 1940s. . . too frail": Curtis to Harriet Leitch 28 May 1949 and 7 November 1949.
21	"Exhibitions" occurred at the Philadelphia Museum of Art, International Museum of Photography at George Eastman House, and the Morgan Library. *The North American Indians* with text by Joseph Epes Brown (New York: Aperture) appeared in 1972.

Select Bibliography

Andrews, Ralph W. *Curtis' Western Indians*. Seattle: Superior Publishing, 1962.

Beck, Tom. *An American Vision: John G. Bullock and the Photo-Secession*. New York and Baltimore: Aperture in Association with University of Maryland Baltimore County, 1989.

Bolt, Christine. *American Indian Policy and American Reform*. London: Allen & Unwin, 1987.

Brown, Dee. *Bury My Heart at Wounded Knee: An Indian History of the American West*. New York: Holt, Rinehart & Winston, 1970.

Bunnell, Peter C., ed. *A Photographic Vision: Pictorial Photography, 1889-1923*. Salt Lake City: Peregrine Smith, 1980.

Curtis, Edward S. *The North American Indian, Being a Series of Volumes Picturing and Describing the Indians of the United States and Alaska*. Cambidge: University Press, 1907-1930; and New York: Johnson Reprint Corporation, 1970.

Davis, Barbara. *Edward S. Curtis: The Life and Times of a Shadow Catcher*. San Francisco: Chronicle, 1985.

Fleming, Paula Richardson and Judith Lynn Luskey. *Grand Endeavors of American Indian Photography*. Washington, D.C.: Smithsonian Institution, 1993.

Graybill, Florence Curtis and Victor Boesen. *Edward Sheriff Curtis: Visions of a Vanishing Race*. Boston: Houghton Mifflin, 1986.

Hodge, Frederick Webb, ed. *Handbook of American Indians North of Mexico*, 2 vol. Washington, D.C.: Government Printing Office, 1907.

Lawlor, Laurie. *Shadow Catcher: The Life and Work of Edward S. Curtis*. New York: Walker, 1994.

Lyman, Christopher. *The Vanishing Race and Other Illusions: Photographs of Indians by Edward S. Curtis*. Washington, D.C., 1982.

Michaels, Barbara L. *Gertrude Kasebier: The Photographer and Her Photographs*. New York: Abrams, 1992.

Rosenblum, Naomi. *A World History of Photography*, rev. ed. New York: Abbeville, 1989.

Royce, Charles C. *Indian Land Cessions in the United States*. Washington, D.C.: Government Printing Office, 1900; reprint ed., New York: Arno Press & New York Times, 1971.

Wanamaker, Rodman. *Wanamaker Primer on the North American Indian Hiawatha*. Philadelphia: Rodman Wanamaker, 1909.

Wilson, Edward L. *Wilson's Photographics: A Series of Lessons, Accompanied by Notes, On All the Processes Which Are Needful in the Art of Photography*, Chautauqua ed. New York: Edward L. Wilson, 1881.

List of Plates